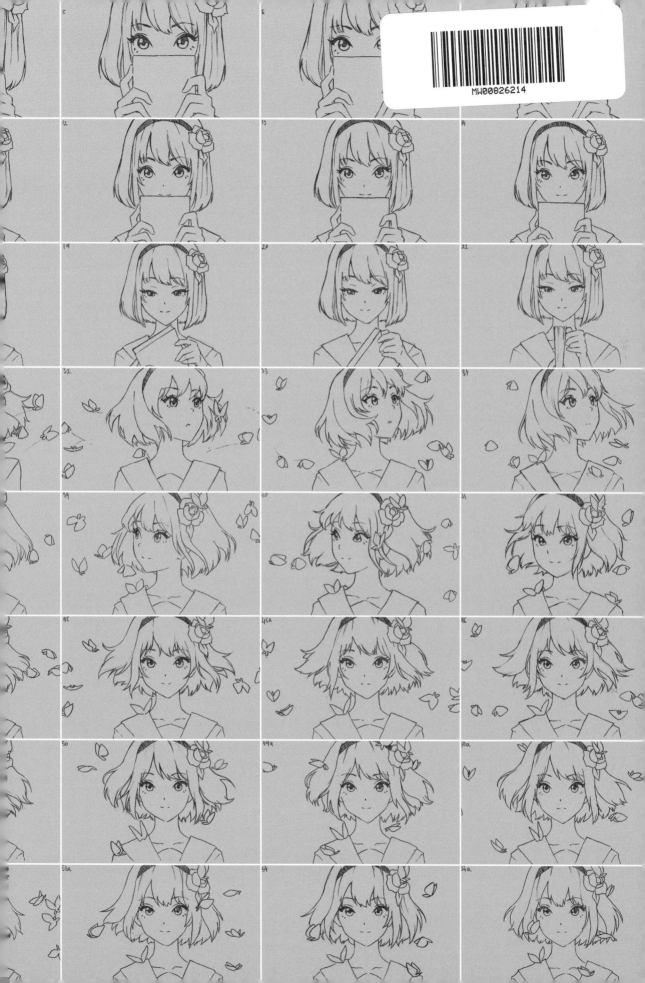

Sketch with Asia

MANGA-INSPIRED ART AND TUTORIALS BY ASIA LADOWSKA

TO MAT

3DTOTAL PUBLISHING

Correspondence: publishing@3dtotal.com
Website: www.3dtotal.com

Every effort has been made to ensure the credits and contact information listed are present and correct. In the case of any errors that have occurred, the publisher respectfully directs readers to the www.3dtotalpublishing.com website for any updated information and/or corrections.

Please note: the views expressed here are those of the author and do not necessarily represent or reflect the views of 3dtotal Publishing.

First published in the United Kingdom, 2019, by 3dtotal Publishing. 3dtotal.com Ltd, 29 Foregate Street, Worcester, WR1 1DS, United Kingdom.

Reprinted in 2020 by 3dtotal Publishing.

Hard cover ISBN: 978-1-909414-66-2
Printing & binding: Gutenberg Press Ltd (Malta)
www.gutenberg.com.mt

Visit www.3dtotalpublishing.com for a complete list of available book titles.

ONE TREE PLANTED FOR EVERY BOOK SOLD

OUR PLEDGE

From 2020, 3dtotal Publishing has pledged to plant one tree for every book sold by partnering with and donating the appropriate amounts to re-foresting charities. This is one of the first steps in our ambition to become a carbon neutral company with carbon neutral publications, giving our customers the knowledge that by buying from 3dtotal Publishing, we are working together to balance the environmental damage caused by the publishing, shipping, and retail industries.

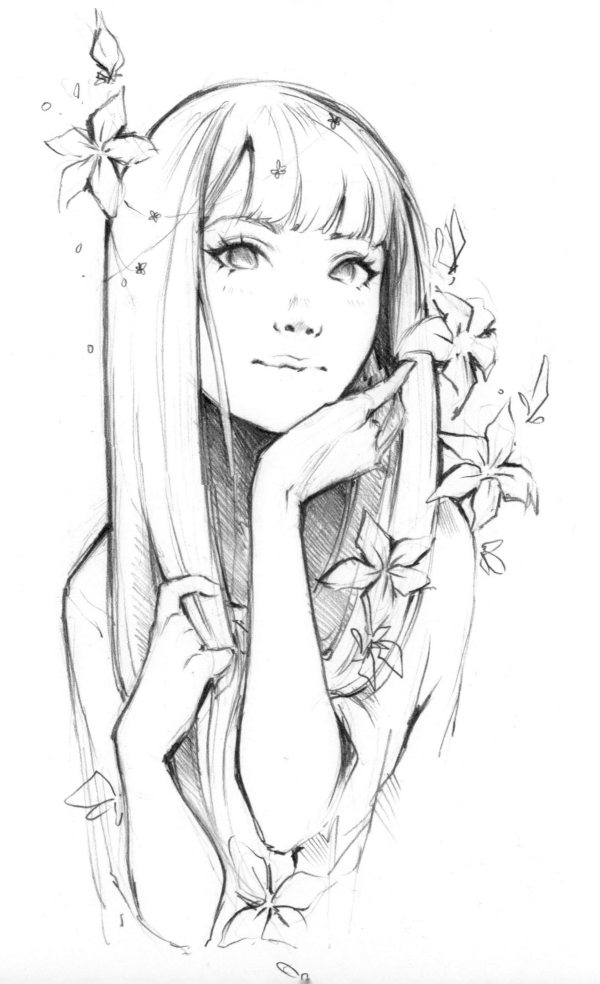

CONTENTS

HELLO !

FOREWORD

It was mid-2017 and I was doing a live demonstration for Copic South Africa at the local art store, *Herbert Evans*, which was being live-streamed on Instagram. It wasn't long and I started getting a string of endless questions from this random person by the name of @Ladowska. She seemed very interested in my process and right after the demo we carried on talking. At the time of writing this, we have hardly missed a day without sharing our artworks with each other, giving feedback, advice, sharing our struggles and experiences, supporting each other when things get tough, and just sharing our lives in general.

I can now say without a doubt that Asia is by far the most valuable person to come into my art life, a life that before her felt... well let's just say, a lot less. Her and I have been through a lot together, so I've been fortunate enough to see how much she's grown and evolved, not just as an artist but as a person too. She is now working as a freelance artist, having made the terrifying choice of leaving her comfortable job as a full-time graphic designer to fully commit to her own artistic way of life.

To work so closely with someone who is so passionate about creating art and taking it continuously to the next level in so many creative ways is extremely inspiring, in ways words will never do justice. She is incredibly hardworking, endlessly on a mission to learn and to challenge herself, and driven enough to reach all of her dreams beyond any and all obstacles that stand in her way.

I now have the great honor to introduce you to a huge milestone of hers – a spectacular manifestation of all her strenuous hard work and passionate love that she is now able to share with you and the world in her very first art book, *Sketch with Asia*.

Much sleep and sanity has been lost in the process of her putting this book together, but she has managed to push through successfully to show that this is indeed the next level that she is after. With that said, I am convinced that you will thoroughly enjoy every page and take away with you a valuable, expanded artistic awareness to help you reach the next level too.

Asia, you're on top and going higher.

Much love,
Warren Louw

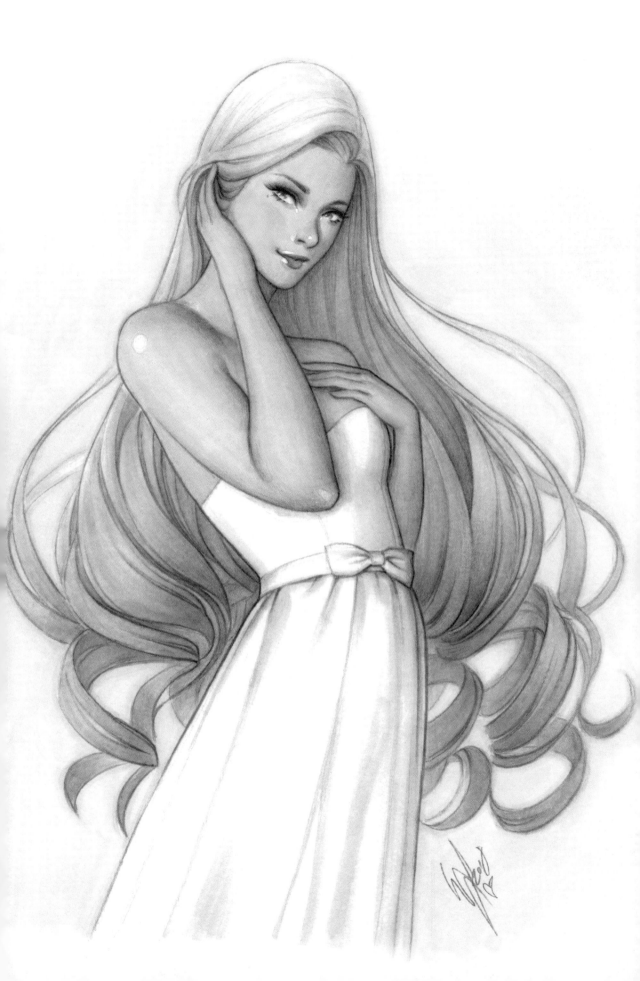

INTRODUCTION

The attraction to characters with big eyes and pointy chins began early on in my childhood, before I even knew what manga was. This style of art was neither popular nor easy to find where I lived, so trying to pursue it seemed impossible.

I remember taking my first manga-inspired drawings to the portfolio review with an established and respected art teacher in 2004, a few years before applying to a senior high school of art. All I heard then was, "If you keep drawing manga, you will never get in to any art school." Feeling ashamed, I hid away all my drawings and didn't draw in this style for many years after. Instead, I focused on drawing still life and landscapes, which I was encouraged to create more of.

Around 2014, I discovered some artists online whose art completely blew me away; every time they posted new drawings, it would make my heart race and I would stare at their masterpieces for hours. I didn't realize at the time, but this was me falling in love with manga-style art once again. Before I knew it, I was doodling myself, trying to imitate their styles, while slowly making my own designs too.

Practice time was scheduled for before and after work and, finally, in January 2016 after having a bad day at work (and not the greatest one at university) I decided to do something to help me both remember and forget that day – I made my first post online on Instagram (instagram.com/ladowska). This new account was a symbol of my fresh start and I intended for it to be dedicated exclusively to my manga drawings. I decided to finally do what I always wanted; it was making me so happy.

It was a small decision to start the Instagram page, but this small decision led to the biggest and most positive changes for me. There was no response straight away of course, but I was doing it for myself, so it didn't matter. It felt great to just have that fresh start. When the first comments from unknown people kept coming, I felt even better and really encouraged, because for the first time people who came and followed my account or left a comment liked my manga drawings! This was amazing after all the negative opinions I had heard about manga, in real life. I also didn't know many people who were into this style of art but suddenly I was able to connect with a whole like-minded community online. It is now my passion to encourage people to pursue what they love and to follow their hearts. This is because I believe it leads to producing our best work and because it is what makes us happy.

I started a weekly Instagram challenge #SketchWithAsia in 2018 – the idea being to help discover passionate people from around the world and to motivate them to work hard and practice. Because the challenge is weekly or sometimes bi-weekly, it stops us (me included) from leaving drawing for later "when we have more time" – a time that often doesn't arrive! Giving a theme saves many from the struggle of "I want to draw but I don't know what!" It also helps me recognize the struggles people face when drawing and lets me offer guidance where I teach how to avoid common mistakes and get better at certain things. Lastly, thanks to the dedicated hashtag, #SketchWithAsia I can look at all the wonderful entries and stay motivated myself!

I cannot believe that following on from my Instagram page and just three years after my first post on there, that I am able to share with you my first book. In the book you can find a selection of my illustrations along with an overview of my approach toward drawing manga-inspired art, and some words of wisdom about how I stay inspired and motivated. I also share the challenges I have faced along the way and offer tips that I wish I had known before starting my own drawing adventure.

It is such a privilege to be able to reach and inspire so many people with my art and I hope that with this book I will be able to encourage others as I have been encouraged myself.

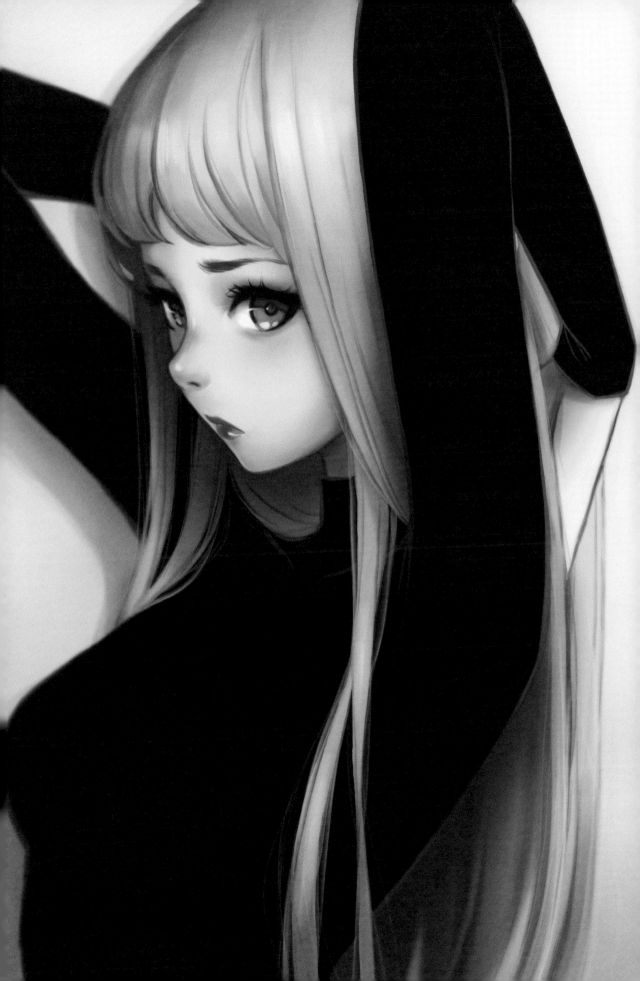

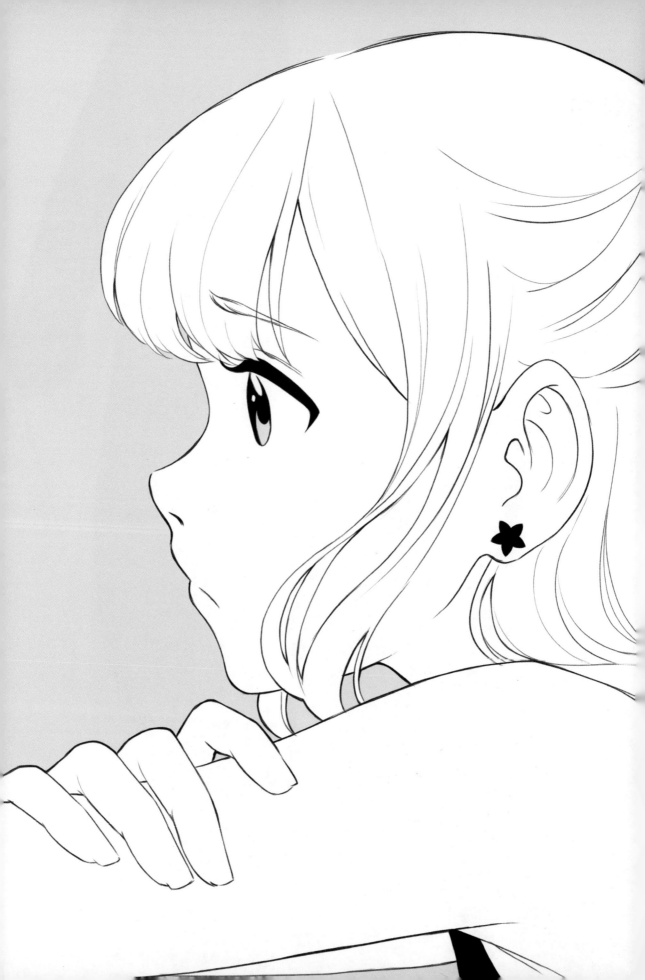

ABOUT ME

I was born and brought up in Poland and art was a big part of my childhood (almost as important as chasing stray cats to pet them or going fishing with my dad!). I think I liked drawing because when I was little there weren't many other things to do in my free time. We had no computers or any other electronic devices, and television was only allowed for half an hour a day (there wasn't much on it at the time anyway!). It was normal to meet up with other children to either play a game outside or stay indoors and draw together. Although we were limited in our options, I must admit that making something from nothing – whether that was building cities from glued-together match boxes or filling in a blank piece of paper with scribbles – was extremely satisfying and I loved doing it.

My family always supported my interest in art, along with lots of other activities. My mum signed me up to many classes after school such as swimming, dance, piano, ice skating, and English language. However, it was the art classes that I also took that I enjoyed the most. Eventually I stopped attending all the other lessons and signed up to even more art classes after school to help me pass exams to enter an arts college.

My parents never told me that I had to become a lawyer or a doctor, so when I decided to continue this path after college I heard no objections. All the hesitation and self-doubt on whether I could make it in life as an artist came only from myself.

After graduating college, I came to the UK to continue studying art at university. I chose to study Graphic Communication (Design) and Illustration. I have stayed in the UK ever since and worked as a graphic designer for a couple of years until 2018 when my online presence expanded and other work opportunities followed, which meant I could take the leap to freelancing as an artist full time!

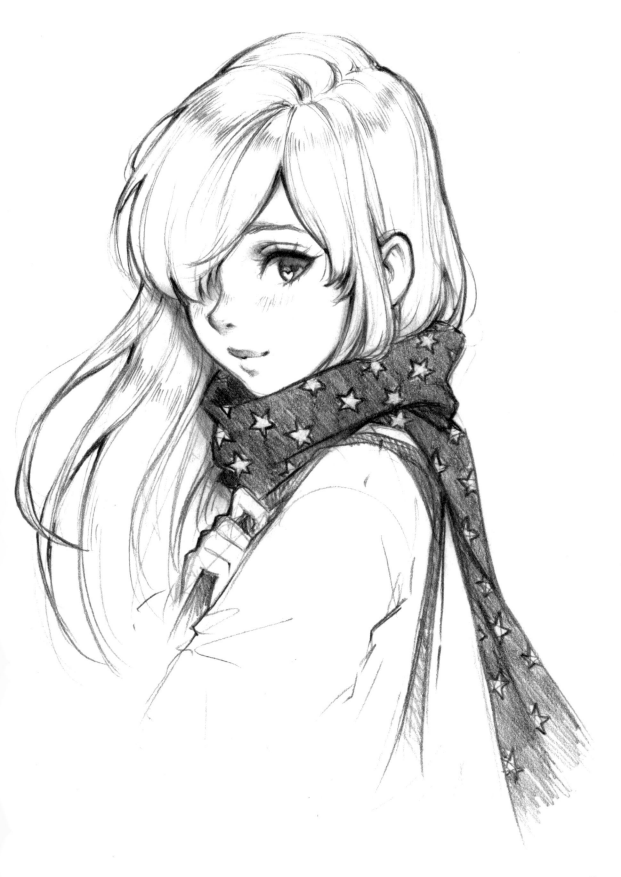

MY WORKSPACE

I mostly work from a so-called "home office", which makes me laugh to say as it was never meant to be an office but over time just became one. It is a tiny room with two desks – one is for creation of traditional art and one is simply a computer desk, where I reply to messages, edit Patreon and YouTube videos, record voice for my voice-over tutorials, and create all my digital art. It is definitely a tiny and clustered space; the walls full of pictures only add to this look.

I have on display original drawings and signed prints from artists that inspire me such as Ilya Kuvshinov, Warren Louw, Artgerm, Omar Dogan, Loish, Cyarin, Ross Draws, and Minmonsta. Looking at their drawings every day is not just pleasing to the eye but it is also a great reminder and motivation to kick-start the day with hard work. My art books and many volumes of manga books are also on display.

On the desk I use for traditional art, I have all my Copic markers on the stand, some Copic refills, many fineliners and Sharpie markers in cups and jars, and two LED lamps. I often work at night, so the lamps are always on. The last thing, which is crucial to my work, is an arm phone-holder. I attach my phone to this and record video processes of my drawings.

On the computer desk there are two screens (three if I am working on a Cintiq at the time), a scanner, a mouse, and a keyboard. And sticky notes. Lots of sticky notes. Actually, sticky notes are scattered all over the room and stuck to walls too. I use them for notes and doodles, and sometimes funny comics and animations.

I also keep a few pencils contained in a pencil case in my bag along with a sketchbook. These are always ready if I go out; I never leave home without them.

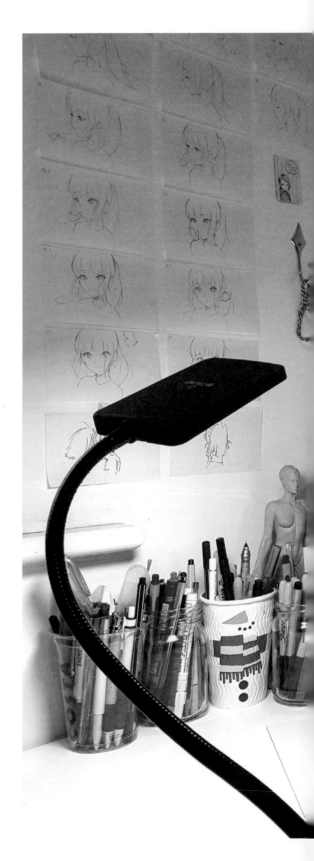

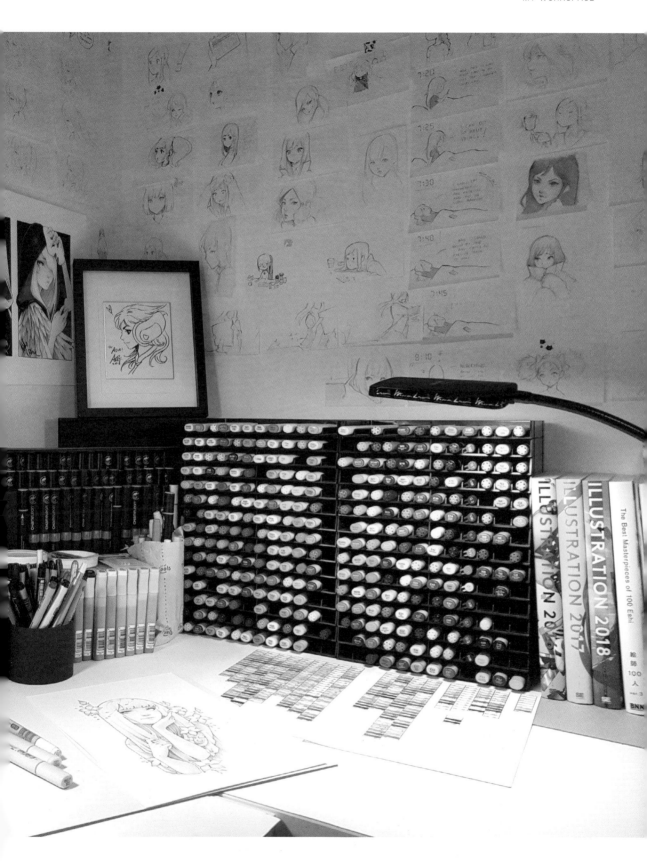

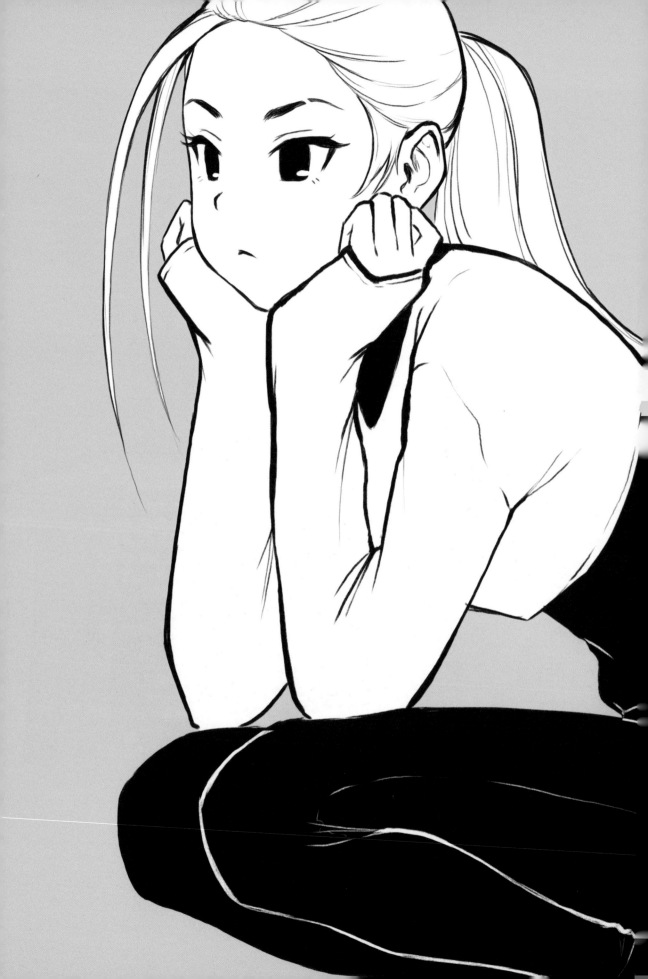

CREATIVE JOURNEY

EARLY INFLUENCES

The person who introduced me to the wonderful world of art was my older cousin, who was studying in art school when I was little. She taught me how to make whole cities from boxes of matches, and tiny people from chestnuts. I used oil paints and pastels for the first time with her. Later, she helped me produce traditional graphics such as linocut, and she talked about other graphic techniques like copperplate and etching while we played together.

The next thing I can remember that had a massive influence on me in my childhood was undoubtedly the *Pokémon* series on television, which I watched from episode one. I am still a fan today and have kept a notebook in which I pasted all my *Pokémon* stickers from bubble gums. I managed to collect all 150 – what an achievement!

Another inspiration for me, in my teenage years, was an Italian fantasy comic series called *W.I.T.C.H.* (written by Elisabetta Gnone, Alessandro Barbucci, and Barbara Canepa). When it came out I became hooked on it immediately. The comics had a manga-style feel and I remember trying to draw a little around that time. The influence of the comic was rather easy to spot in my works.

I definitely need to mention here my favorite manga of all time, which was also the first manga series I read: *Chobits* by Japanese manga collective "Clamp." Its visual side is mind-blowing with charming characters, frilly dresses, flowing hair, and details in every panel. The story is close to my heart, too. Throughout all eight books it beautifully depicts the development of characters' feelings and their struggles to understand why they feel the way they do – with the world around them condemning anything outside of the stereotypes – making them suppress their true feelings.

My teachers made me believe that drawing cartoon and manga-like characters was something to be ashamed of. I was told that I should never show my manga-style art to anyone and that it is a low league of art that has no future. I took their advice to heart unfortunately, and I will always regret that. It made me feel ashamed and I hid away what I loved so dearly for the next decade. It took courage to finally break through and start drawing from the heart and I have the internet to thank for that. Had it not been for the wonderful community of artists who create and share their pieces in this majestic genre, I might still be too ashamed to draw in the style that I am most passionate about.

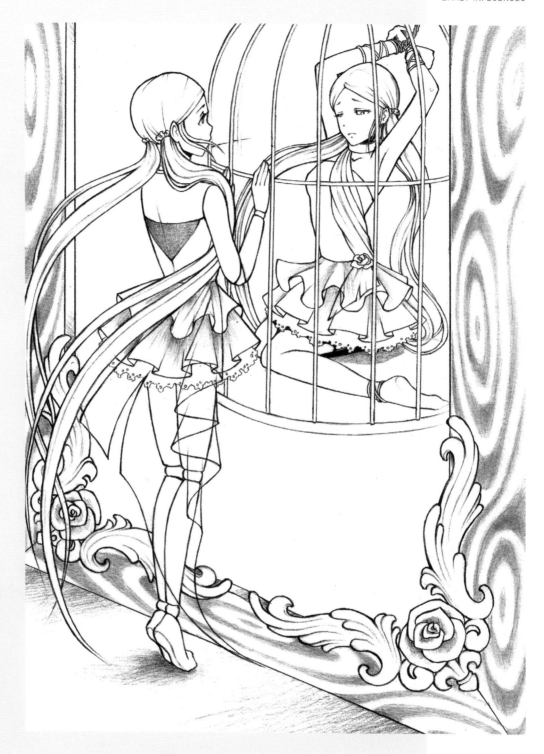

THIS PAGE: A panel from a short manga I created for a university project. It was about a unique living doll who felt trapped and unhappy for not being allowed to do what she wanted. Its art style was influenced by *Chobits*. I felt at the time that I was given unconstructive feedback from the teacher who kept advising me to change the project. I can see now that I didn't tackle the task particularly well and this was mainly where their opinion was coming from. However, I do wish this manga style could have been encouraged instead and that I could have received more help and guidance.

EARLY WORK

Looking at my early drawings it seems I was keen on drawing imaginary characters and animals, and creating small comic strips with funny stories. While I still enjoy doing this, much of my approach has changed too. Over the years I have gathered knowledge and developed an awareness that is now a big part of the drawing process. When I first began to draw I focused on producing the idea that I had in my head and, in many cases, when it wasn't working, or when it wasn't looking on paper how I had imagined it, I would simply give up. If the same thing happens to me today, however, I am able to easily identify why this is happening and which steps I should take to overcome the problem.

Many artists don't realize that drawing, just like any other skill, needs to be practiced and nurtured. It needs passion as well as dedication, and is a journey of many trials and errors. This isn't something I would tell my kid-self of course! I would still say, "draw your heart out and never stop." I think if I said, "You need to polish up on anatomy and proportions," it would ruin the fun and wouldn't be very encouraging. Although, of course, learning art fundamentals is very important!

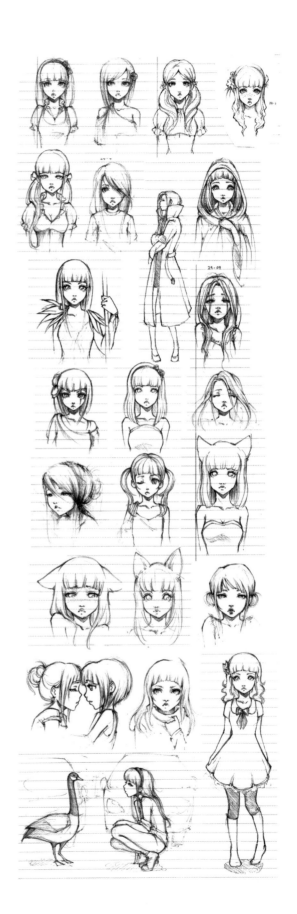

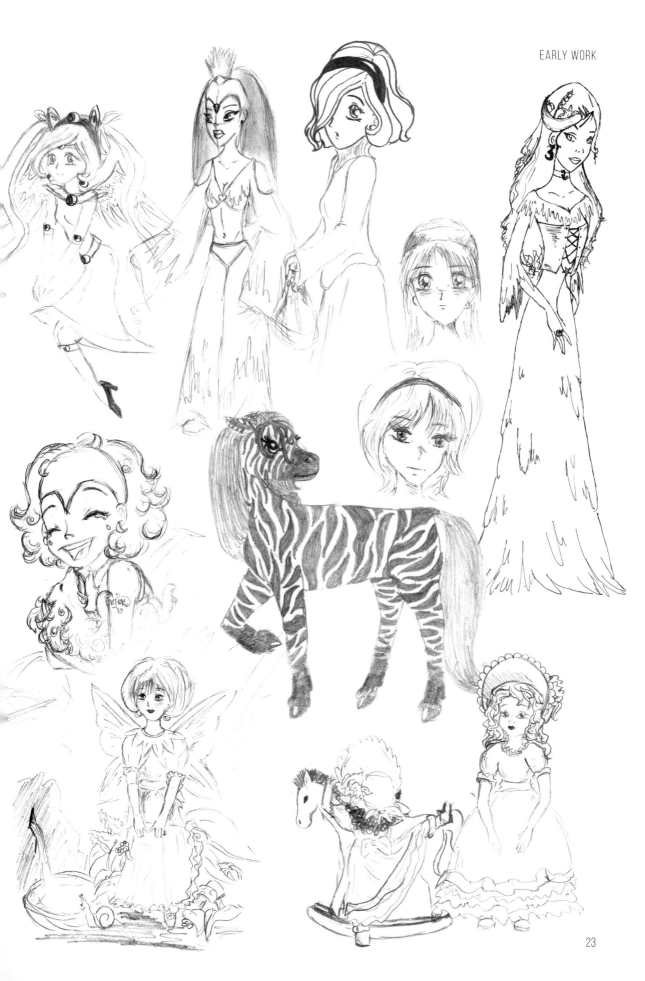

HYPERREALISM

Hyperrealism was a style that came naturally to me and I worked out how to achieve the best results with it. I used to take on commissions and copy photographs I found on the internet, which I shared on my social media channels. The process of creating this kind of art is completely different than it would be for any other drawing. You can spend an immense number of hours on such a piece, perfecting it; for me this could be between 50 to even 200 hours! However, while I like that there is no rush to produce a hyperrealistic artwork, I found this style very difficult to make a sustainable business from as it took too long to turn round a piece and get it back to the customer, for insufficient money.

I began to draw in this style while attending art classes at the age of thirteen. The usual practice task given to me by the teacher was to draw an object in front of me. At this stage, I didn't understand color theory, perspective, or composition, so I was attempting to make it look as much like the object in front of me as possible by simply following my intuition. For the next four years of art school I was exposed to more art styles and challenges, but I still followed this same technique; trying to imitate the reference as closely as possible. I often traced the outlines in order to avoid any possible mistakes in the sketching process and used photos for reference. By using photographs I didn't have to think about composition or lighting as they were already perfected by the photographer.

Looking back at my process and ways of practicing, I can see I didn't learn much. The methods I used were ineffective and shallow. The objective was to create an artwork that would look as close to the reference image as possible, and not to learn the principles of drawing. I didn't learn to break down the process to identify shapes, lights, mid-tones, or shadows. I didn't try to approach textures as I should have; all I did was to patiently fill in the page with graphite, relying on the reference. However, I did learn to master the pencil. I learned this tool inside out and everything about different pencils and methods of using them. To this day, the pencil is the tool I feel the most comfortable with as it hides no secrets for me anymore.

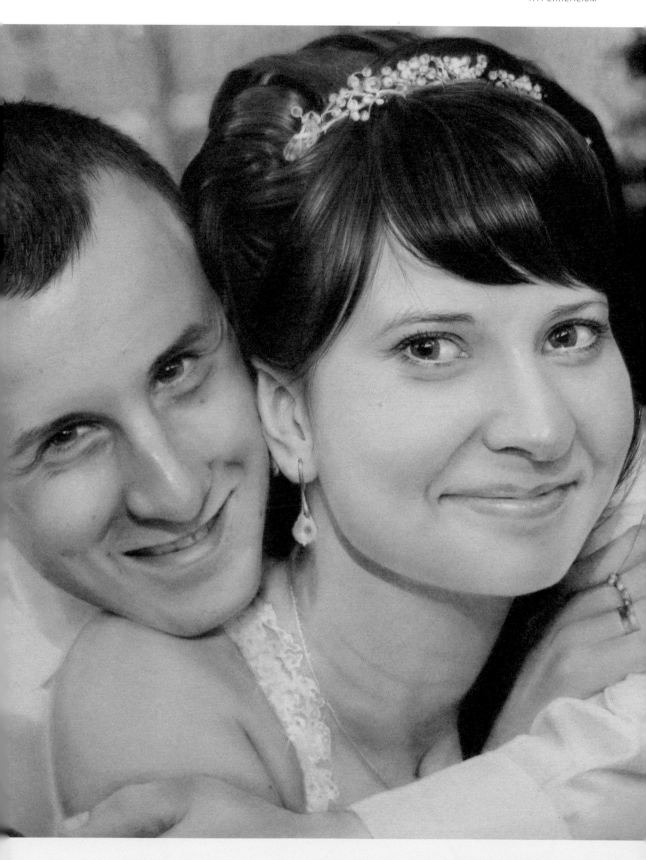

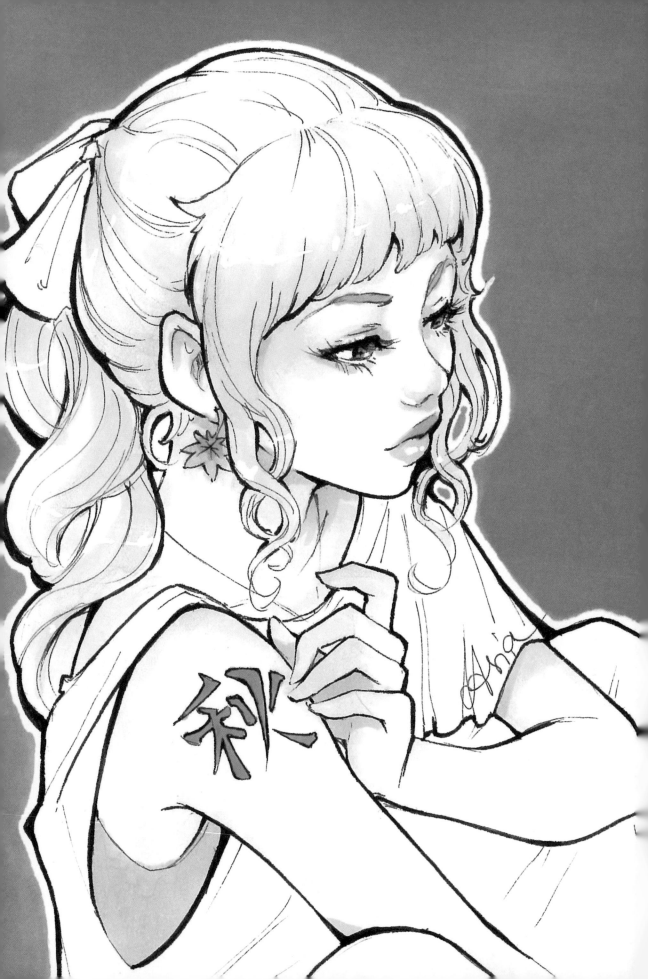

INSPIRATION

Why is one's favorite color black, or red, or blue? Why do we like certain foods but not others? Why drawing and not cycling as a hobby? Why manga? There are certain things that are just the way they are, and they are hard to explain. It is difficult for me to say why I find manga-style art so captivating and why everything Japanese takes a special place in my heart. I don't know why, but I know exactly how looking at manga-style art makes me feel, and how calm and happy I am when I am creating it myself. It may be the colors, the lines, the big manga eyes, or it may be something else, or even a combination of factors. I feel very inspired while reading manga and it makes me want to draw. When watching anime, I tend to be very critical and uninterested in the plot and instead focus on the lines and style of the animation. I often rewatch certain scenes endlessly in slow motion to learn about how they were animated. Despite being put off the manga genre by my art teachers, I still nostalgically admired manga art whenever I came across it.

I am inspired by so many things that it doesn't take me long to get started: color schemes that look nice together, a memorable moment, a word, a song, an interesting sound, somebody else's artwork, an evocative smell... It can be anything!

A big part of my artistic journey was discovering the work of Ilya Kuvshinov online (instagram.com/kuvshinov_ilya). After I had given up on art entirely, seeing him post new work roughly at the same time each day made me want to go online and wait for the new work to pop up. I was just admiring the artwork at first, but then it suddenly made me want to pick up a pencil again. At the time, I was working full time as a graphic designer while trying to finish my degree. Nevertheless, I decided to dedicate half an hour every morning to creating one quick sketch. This was a small, but very important, first step I made in drawing manga-style art.

This new ritual lasted for around a year and gradually I was able to not only draw bigger and more complex sketches in the same amount of time, but I could hardly stop drawing when the time ran out. Eventually I was sketching on lunch breaks, on the train to and from work, and in any spare moment I could find. I was drawing just for myself, so I didn't post anything online or show anyone what I was doing. I had discovered one little thing that made me happy and that I was looking forward to doing every day, and it was all thanks to Ilya.

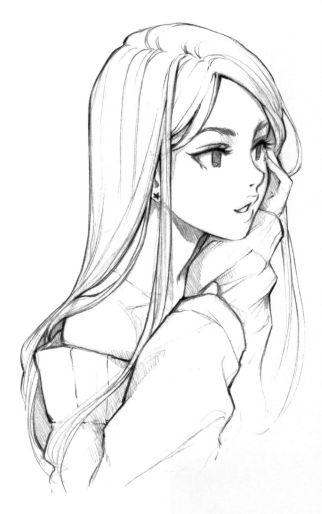

Another artist who played a major role in inspiring me was Omar Dogan (instagram.com/omardogan1976). His works are undoubtedly mind-blowing, with a distinct style and strong color schemes as well as perfect anatomy, perspective, lighting, and composition. Omar's manga, *5th Capsule*, has made an unbelievable impact on me and left me sleepless for weeks considering, simultaneously, what might happen to the characters in the next chapters and how I could possibly achieve such a level of mastery in drawing myself. Omar has been really kind to me and was the first artist that I greatly admired who gifted me an original drawing. It was the first drawing I had ever received, and it made me feel like I was a part of this beautiful, friendly art community. Every day since then, I have been looking at the drawing, which is hanging a few centimeters over my computer screen. It gives me strength and serves as a daily reminder to be kind and helpful to others, motivating me to work hard and never give up.

I think it is important to have a role model in another artist; someone to look up to that always inspires you and makes you remember to follow your dreams. To me that person is Warren Louw (instagram.com/artofwarrenlouw). Warren's influence goes beyond drawing itself. After admiring his creations online for a while – his color choices, perfectly balanced composition, storytelling, and mastery in both traditional and digital art – I stumbled upon a live online session where he was answering questions. I had so many questions, the hour wasn't long enough! I was extremely lucky that he was willing to answer many more questions after the session had ended.

Talking to Warren was both an amazing experience and a terribly depressing one; I realized how little I knew and how much more there was for me to learn and discover. It was both exciting and terrifying! Over time, Warren has become my mentor on my creative journey, helping me to overcome struggles and not letting me give up, and in this process also becoming my best friend. In my opinion, there is never an end to the learning process. Also, meeting a person who is just as passionate in what they do as you are, who wants to help, collaborate, and share his experience has brought a new meaning to art for me.

"THERE IS NEVER AN END TO THE LEARNING PROCESS"

OPPOSITE: *Enchanted* – my collaboration artwork with Warren Louw
Artwork © Asia Ladowska and Warren Louw, 2018

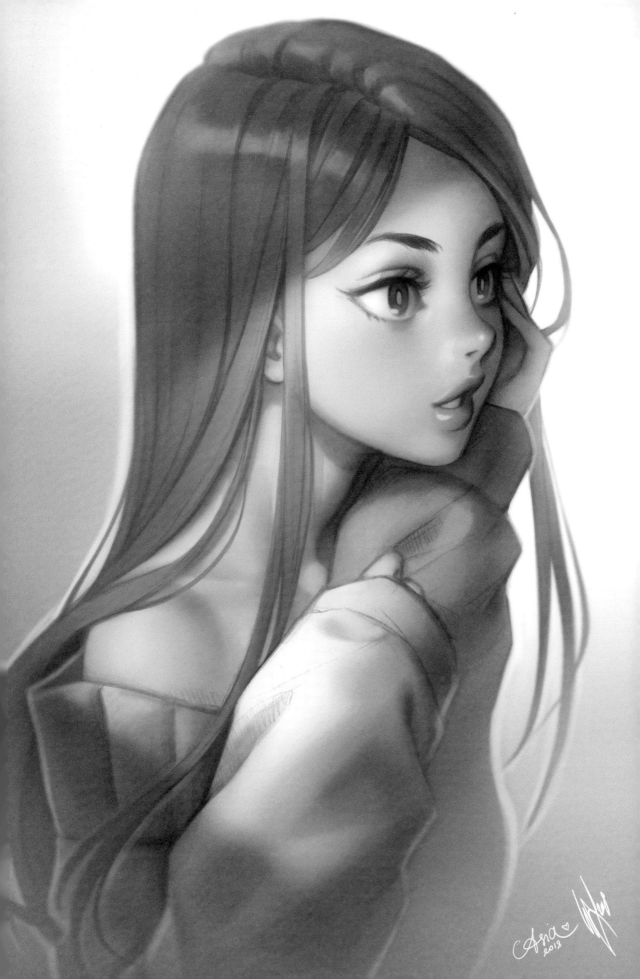

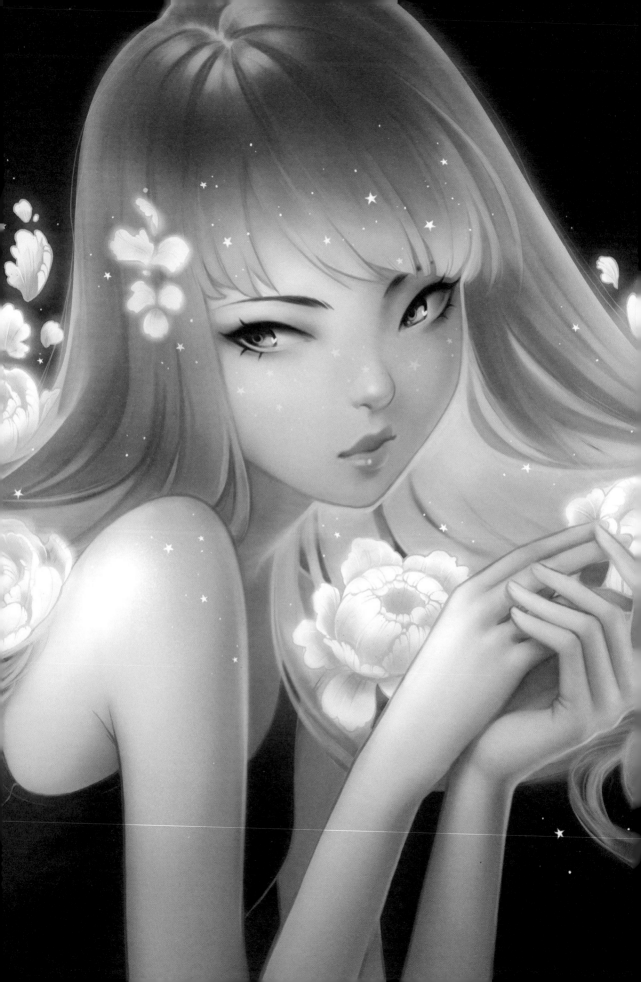

Working with Warren has been beneficial to both of us. We have shared insights into our processes and were able to share our knowledge. After a while we also managed to gain the confidence to share works in progress and ask for feedback or even work on some pieces together. Learning and accepting your strengths and weaknesses is very important for improving your creative practice.

The art of others is almost always an inspiration to artists and something that drives our will to draw, but we must be careful. In the new digital era, when anyone can become an artist and a teacher, we must remember that often many of those artists are learning themselves, and can make mistakes. Of course, while studying and being inspired by other people's work is valuable, it is important to be ethical about how you use these studies. If you are copying someone else's work to learn from it, I would generally advise that you keep these studies to yourself and do not share them online.

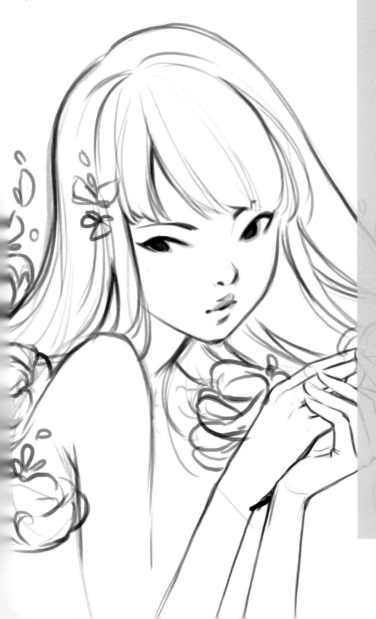

ADVICE

When you first start out, making a piece of art can be an impossible mission. So much thought is put into "what to draw," that before you begin you can already feel exhausted! Remember, the drawing process is all about the journey and not the destination – developing your technique and improving, not creating perfection (at least it shouldn't be at the beginning). All it takes to start is to simply put pen or pencil to paper. Don't put too much pressure on yourself; you should practice and perfect your own style at your own pace.

Studying existing artwork by other artists can inspire you, helping you to learn about using new mediums and techniques and to discover how other artists have tackled the same problems we all encounter. However, this is not something I would recommend to budding artists as a standalone method. First of all, by *studying* I have to explain that I mean *drawing*, and even more specifically, *copying*. Studying artwork by simply looking at an image is limiting and you only start to understand the nuances of the design when you attempt to replicate them. You also need to actively consider and learn fundamentals, as I mentioned earlier with regard to hyperrealism (see page 20).

To help you come up with ideas of what to draw, beyond studying the artwork of other artists and taking inspiration from your surroundings, you can look to books. When everything is gray and uninspiring, and I am struggling to find inspiration around me, I reach for the stash of books I brought back from my voyages to Japan. These are thick volumes filled with designs by various artists. (Then I just need to remember to draw instead of looking at them for hours!)

SOCIAL MEDIA

Using social media can be life changing and it certainly has been for me. While working full time I was only able to draw at night but I made sure to consistently share my manga-inspired artwork online. I am extremely grateful that thanks to the amazing support I received, and exciting opportunities that followed as my online audience grew, I was able to leave my day job and start drawing full time. The online art community is a wonderful world predominantly filled with encouraging and kind people, many of whom keep me going when my motivation is low.

Social media can be a negative as well as a positive place, though. Everybody can get lost and everybody can get found there. Everybody can speak, and everybody can look at whatever they want and express their opinion. It is very much a jungle, and for artists it is no different. Yes, it is a great source of inspiration and an amazing place to grow a community and make friendships for a lifetime but, sadly, there is also a lot of toxicity on social media. Making friends, learning from others, reading lovely comments, and sometimes getting constructive feedback is precious and more than worth the effort, but there is also a certain percentage of people who will be jealous and unkind. They may accuse you of copying or point out your weaknesses.

The public platform of social media can create a pressure that is hard to handle, by making demands on your art and judging you harshly. Many of us artists are sensitive people who just found a little courage to share our art, so facing online bullying can be extremely discouraging. In these moments it is important to remember that art is what makes us happy and that we do it for ourselves, and nobody else can tell us otherwise.

Another thing the internet holds for many of us is the potential for procrastination! Social media provides an endless supply of resources and I can look at beautiful images for hours only to realize my inspiration is long gone. However, if you can find a healthy balance of social media versus the time spent on other personal and professional aspects in your life, it can be used to great advantage. I am following my love and passion thanks to social media now, but I always remember to keep art my priority. It is sad to see people on their social media sites measuring their worth and success by the amount of likes and follows they have; making their goal to get more followers and not improve their art.

What is even more beautiful than growing as an artist is being able to connect with a community of equally passionate people. Social media provides the perfect place for communication, where we can learn and share our knowledge, get inspired and inspire others, and make friends. I always try to be active online to connect with other artists, answer questions, or share tips about my drawing techniques. I love being part of the creative community; just as others helped me when I was starting out, I strive to do the same and help budding artists achieve their dreams.

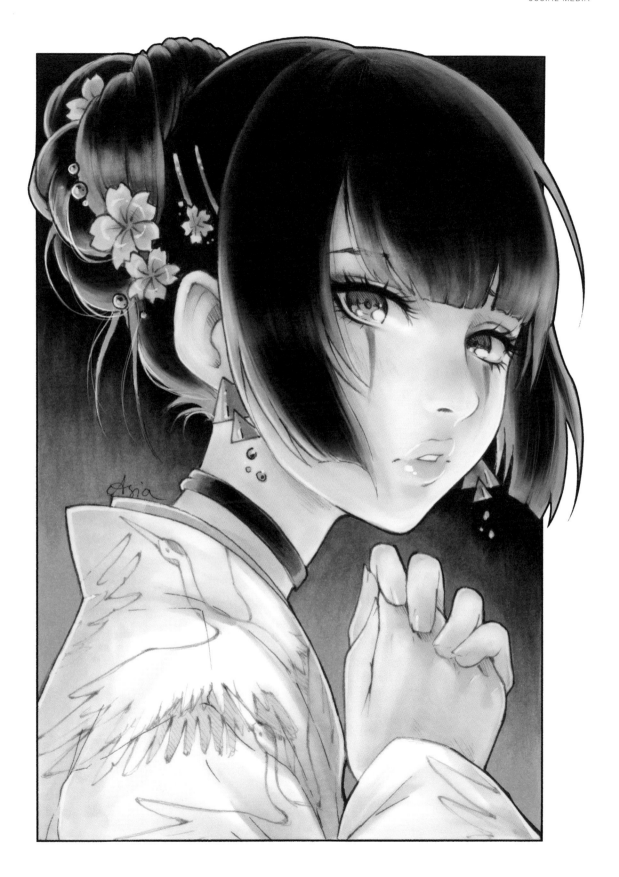

PROGRESSION

I really love online challenges. Whether the challenges originate from just one artist's page, or the popular seasonal challenges many people take part in such as #Inktober (inktober.com) in October or #mermay (mermay.com) in May. Taking part in online challenges is beneficial to beginner artists as well as professionals. Even professional artists have their weak points or certain things they don't like drawing.

The Inktober challenge was started by Jake Parker in 2009 and is extremely popular on all social media platforms. The brief is to create one ink drawing a day in October and post it online. There is an official prompt list for those struggling with ideas as well as many alternative lists created by different artists, but in my opinion the most important thing is to just focus on creating a new drawing every day and keeping at it. This can be challenging on many levels: finding time, staying motivated and creative, as well as trying to keep your works simple so they can be completed within the allotted time frame. In my first year on Instagram, when I had no plan or direction of what to do, Inktober not only kept me motivated but also helped my drawing improve by forcing me to draw regularly. Across these pages you can see the progression of my Inktober pieces from 2015 through to 2017.

Life will throw so many reasons at you to abandon the challenge that you may start to question the importance of creating art altogether! I do always try to take part in Inktober, even if it is not always successful. It inspires me to challenge myself throughout the year and focus on the tasks and goals I set for myself, including progressing with my art.

Eventually, I decided to make my own challenge on Instagram, which I named this book after: #SketchWithAsia. The idea being to connect with passionate artists around the world and motivate them to work hard, practice, and progress; believing challenges can teach everyone a valuable lesson about their artwork. Every week or two, on a Friday, I choose a theme that anyone can join in with and submit their images to.

OPPOSITE: Images from Inktober 2015

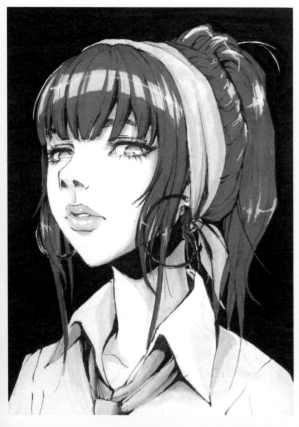
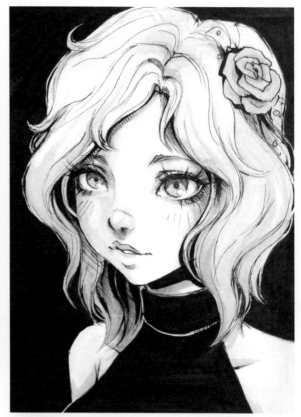
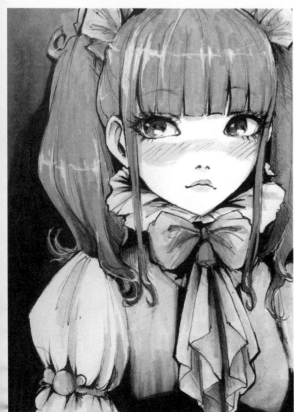
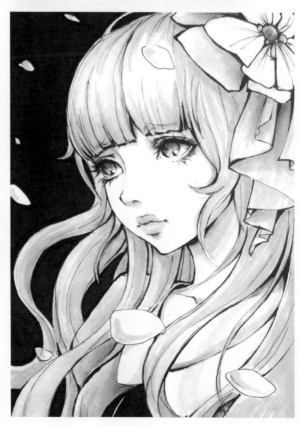

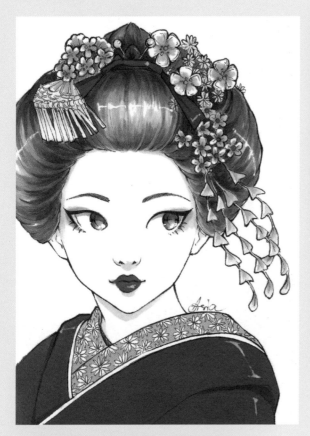

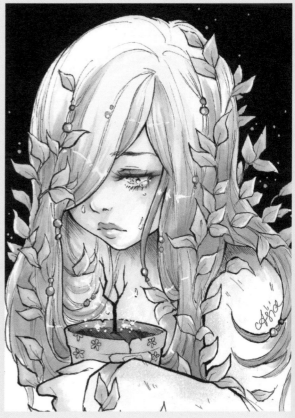

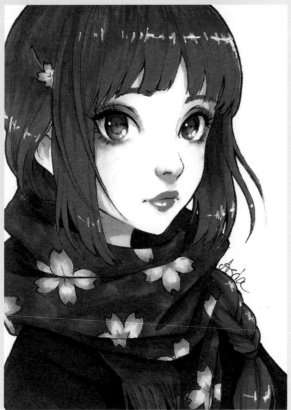

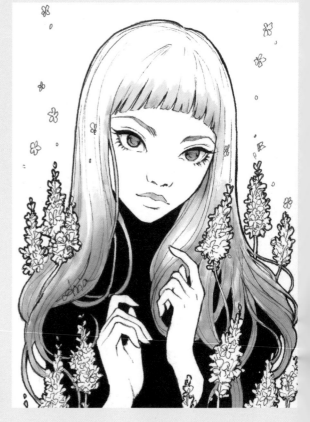

"WORKING ON A STRICT BRIEF CAN HELP TO GROW YOUR CREATIVITY"

This challenge has been a great source of motivation for me and even if I don't feel like drawing on that day, I don't want to disappoint participants by failing to submit a new theme. Seeing all the amazing entries gives me the strength to stay positive and never give up. It is so heartwarming to see how some of the people participating regularly improve their skills so quickly!

Although working on strict briefs with these challenges may sound limiting, it provides great practice for artists willing to work for clients in the future. It is very similar to the type of brief you might receive when working as a freelance illustrator. For example: theme, subject, and media are often chosen by the client and then what is left for you is to depict your vision of somebody else's idea.

Working on a strict brief can also help to grow your creativity. What I used to struggle with was having an empty page in front of me, with absolutely no limitations. In those situations, I would end up really stressed out and under pressure to create something amazing and better than anything I had drawn before. If I had no set theme, I would just keep starting over and over again, hoping that the next sketch would look better than the previous one. This felt like waiting for a miracle! At the end of such a creatively painful day, I would end up really disappointed with myself, with a bin full of crumpled paper. I experienced this often when first starting out as an artist and I had no idea why. When I started to treat art more seriously and accepted my first commissions for clients, I was suddenly more creative, motivated, and could easily define what my weaknesses were.

BOTH PAGES: Images from Inktober 2016

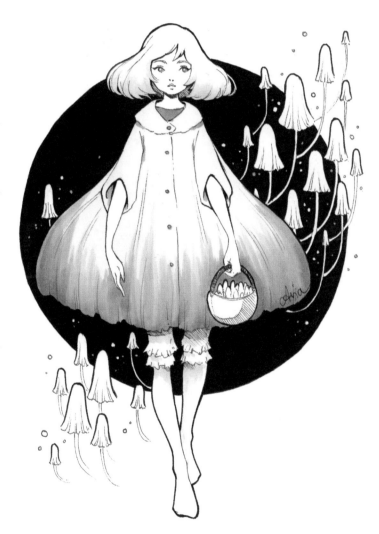

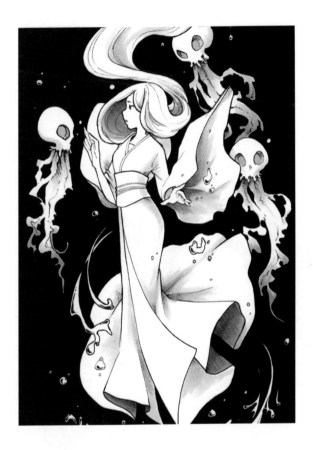

ADVICE

Sometimes it is good to limit yourself in a way that still allows for creativity. It is important to keep at the task and try to make it work, especially when you don't think it is working at all. However, if that is a problem and you still face obstacles with your sketching, preventing you from progressing, it is good to take a break and work on something different. Push yourself with alternative sketches, instead of keeping to your comfort zone or a strict brief.

You might be avoiding drawing difficult shapes, but rather than avoiding them, just keep tackling them. For example, there was a time when I always drew hair over characters' ears because I wasn't happy with how my drawings of ears looked. Realizing that I needed more practice in this area, I studied ears and concentrated on getting them just right before moving on to the rest of the image.

To help develop your drawing skills faster, I recommend studying the fundamentals such as composition, anatomy, and perspective. Use forms you see around you, in nature or everyday situations. Although, I also know that this would not have motivated me to draw initially at all! So, for budding illustrators, I would advise drawing as much as you can without concerning yourself with the fundamentals – simply follow your passion. When you are sure that this is what you love, and you want to develop your skills further, it is then time to start researching to fill in the gaps.

"TO HELP DEVELOP YOUR DRAWING SKILLS FASTER, I RECOMMEND STUDYING THE FUNDAMENTALS"

OPPOSITE: Images from Inktober 2017

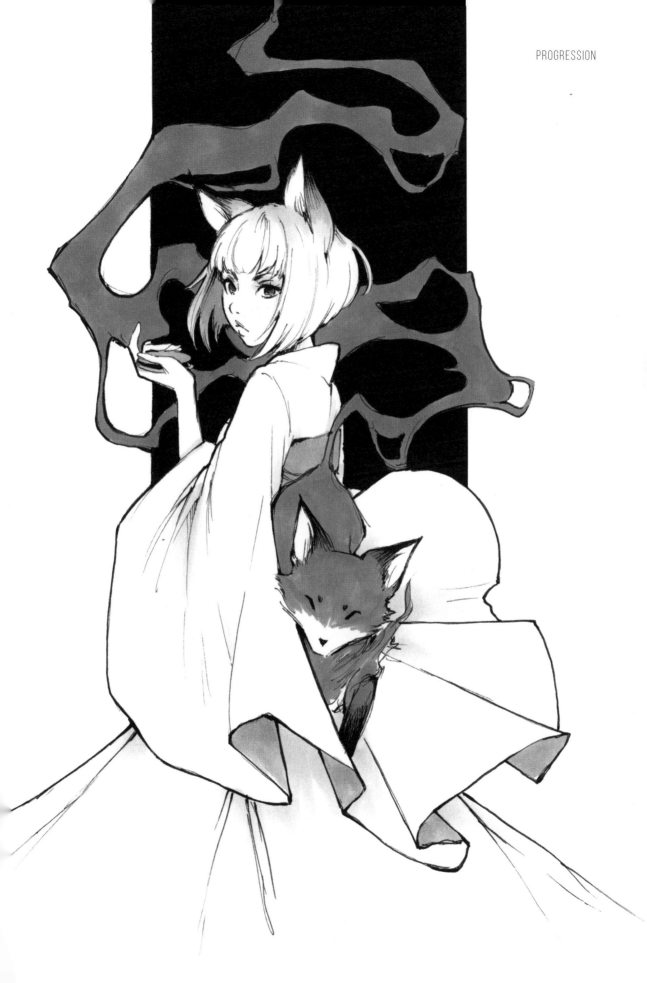

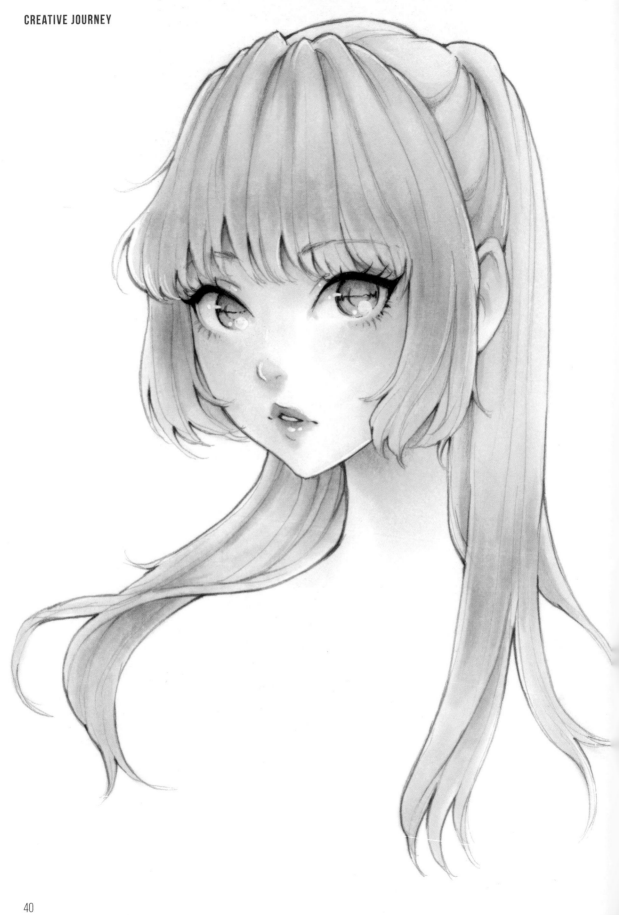

MOTIVATION

I find joy and motivation in hard work. I feel satisfied and happy if I work hard and I look forward to the next day to work hard again. There are two sayings I have heard about turning your passion into your career. The sentiment of the first is: if you do what you love and turn it into your job, you will never feel like you are working. The other is quite the opposite: if you turn your hobby into a job you will suddenly have no free time or rest, and you will work seven days a week. There is truth in both; it is up to you to decide which one is closest to you. It is also about creating a healthy balance.

For me, the biggest source of motivation is that every day brings new opportunities, new ideas, and new projects to work on. Even if a project lasts longer and takes up a whole year, it is still varied and enjoyable. There are always challenges ready to be faced and things to be learned. I don't need any other motivation to draw – there is an undying fire that fuels me! There are, however, many other aspects to life as a self-employed artist that require my attention and these are the times I struggle to find motivation the most. As a freelance artist, tasks such as editing tutorials, replying to messages, shopping for art supplies, filing tax returns, and other general administrative duties are just as important as the art. In an ideal world I would draw all day long, but in reality there are other jobs to consider too.

I also experienced a huge lack of motivation when working in a full-time office job. I felt burned out and each day became a struggle. When I realized this and was in a position to draw full time, I decided to quit my job to work hard on what I was most passionate about – drawing and painting.

There are days that are harder than others, when I feel low about my drawing skills or where there is too much work piling up, but I know that once I get through it, I will feel strong and powerful again, like there is no mountain I cannot move. I try to remember this feeling and think about it every time a day like that comes again. Days full of low self-esteem, when we feel like we can't draw, are commonly known as artist blocks. You can easily come across this widespread problem in the online art community.

Low self-esteem comes from how we perceive our own art, because it is not really possible to suddenly get worse at drawing! This feeling often occurs when we encounter a stressful situation, such as a challenging or important commission that isn't working how we would like it to. It is normal to feel this way. I recently read about Pierre-Auguste Renoir, a leading Impressionist painter, and how when he received a commission from the art ministry and the stakes were high, he made six attempts to create the final painting. The idea of such a serious commission made him doubt himself and paralyzed him with fear. Although this happened in 1891, it is still very relatable today. These pivotal moments in life can be good and bad; they push us to learn and improve, but on the other hand, they can be crushing and can result in artists quitting art altogether. It does happen to me, and I haven't found one solution, but there are a few that I find helpful – they are detailed on the next page.

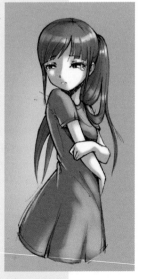

ABOVE: Image drawn in 2014

OPPOSITE: Image redrawn in 2018

ADVICE

First of all, I take a step back and think about how much happiness art can evoke and why I enjoy it. Second, I stop comparing myself to others. It is difficult, when seeing amazing artwork online, to not compare yourself with experienced and highly skilled artists and decide that you are not good enough. You may be impatient in wanting to master a refined and polished technique, but you should pause and enjoy all of the beautiful experiences you can gain while learning. It is almost never about the results, it is all about that important journey.

Sometimes, I look back at some of my very old drawings – which always make me laugh and cheer me up! I try to redraw them to see how far I have come. For the best results, I advise only using this method once every few years to see more noticeable changes in your skill level and style.

Another useful tool for getting through creative block is studying. Studying from life and photographs helps me to work on areas of drawing that I want to develop and improve. Some artists recommend taking a break, to take your mind off the negative thoughts and reflect on your artwork when you return, but instead I need to work through the design issues that are bothering me, developing my skills further to tackle the thing that is blocking me. For me, taking a break, especially if it is for weeks or months, will only have a negative impact on my art. Find what is right for you and don't forget to stay positive. We are our own worst critics and the world will never be a better place if we make it hard for ourselves and each other.

To avoid burning out and to keep yourself interested in art, make sure to explore and experiment as much as you can. There are so many subjects to try: landscapes, people, animals, weather, light, still life, architecture, fantasy worlds, creatures, spirits, and so many more! And there is a vast variety of techniques and mediums to practice with. From digital to traditional art, sculpture, and handicrafts, the possibilities are never-ending, and through exploration you might reignite your passion.

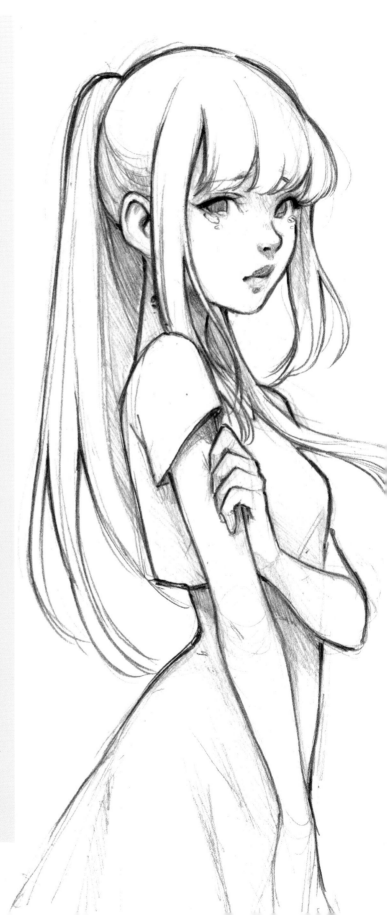

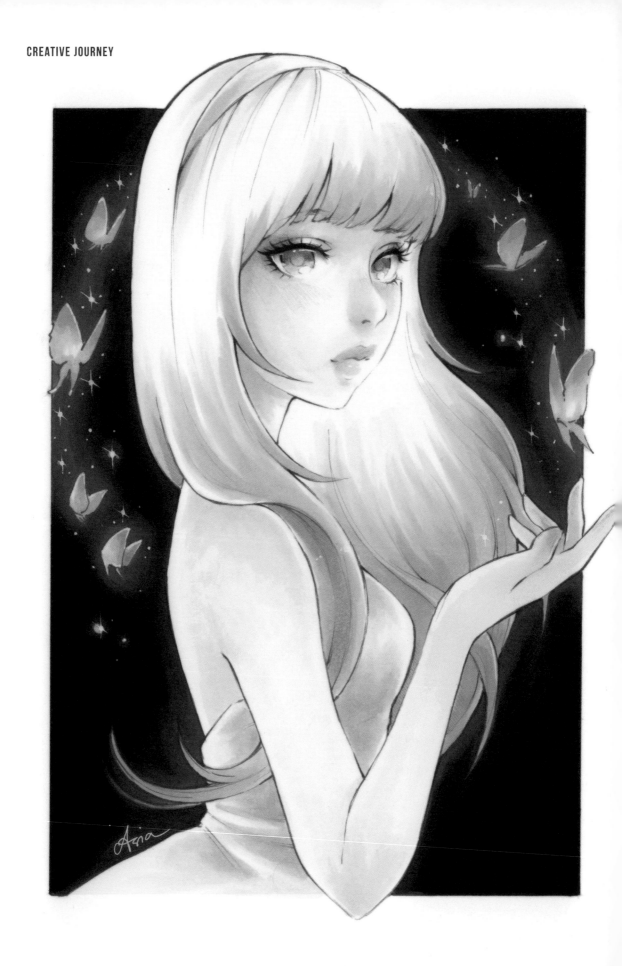

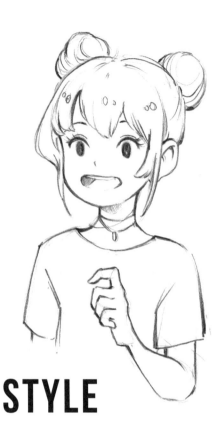

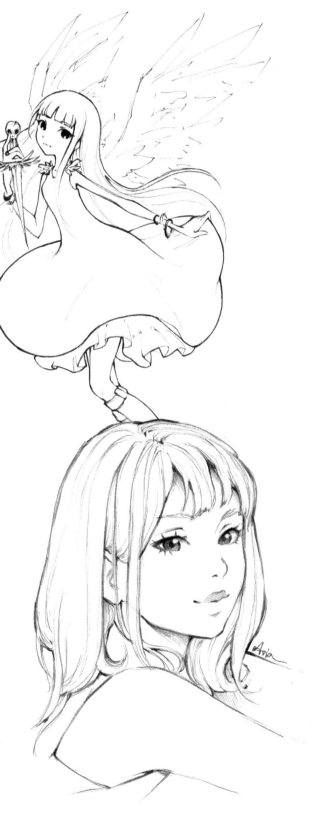

STYLE

I often get asked about my manga-inspired style, but I find questions about style the most difficult to answer. I believe style is very much about our own tendencies, about how and what we draw. There is a theory that style is just a pattern of mistakes that are repeated. I don't know exactly where style comes from, but I believe your style is developed by the inspiration you choose, the techniques you are drawn to, and the workflow that suits you. Different external factors influence your work hugely, and form your style.

I knew that all I ever wanted to do was to draw and draw well. I studied what interested me: nature, and my favorite painters and illustrators. To budding artists that often ask me how they can find their own style I have one answer – don't look for it. Keep drawing and improving your skills and your style will grow. If you copy one artist however, you will always be in the shadow of that person, so make sure to study as many of your inspirations as you can. My objective is not to draw like someone else, but to always learn new things and improve at what I do.

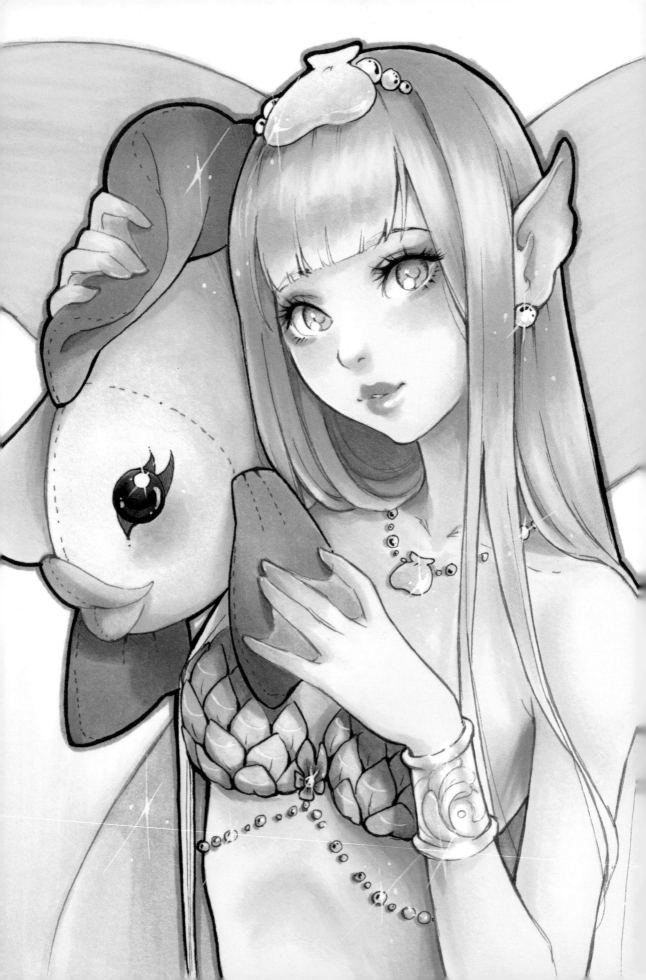

ADVICE

Finding a style doesn't happen overnight and if you feel like you can't find it, stop looking for it and I am sure it will find you.

When your knowledge of the fundamentals gets stronger, much of your drawing will happen intuitively, but I know how frustrating it can be at the start. Do not be discouraged. Stay passionate and strive to learn more, achieving small goals one step at a time. This book showcases the beginning of my art journey. I am nowhere near perfect at what I do, but I push myself to keep improving and drawing no matter what, because this is what I love doing the most.

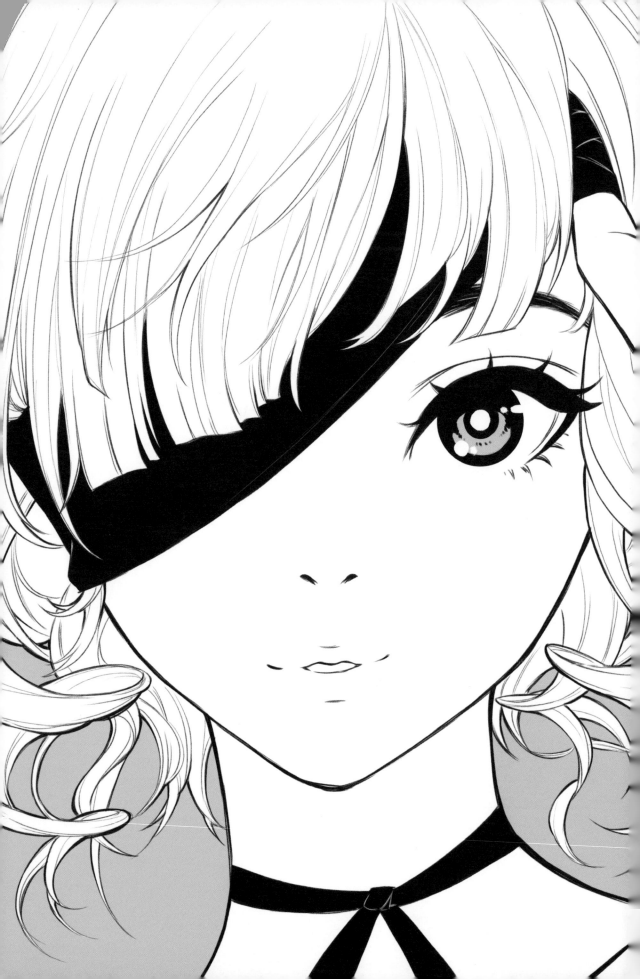

GALLERY

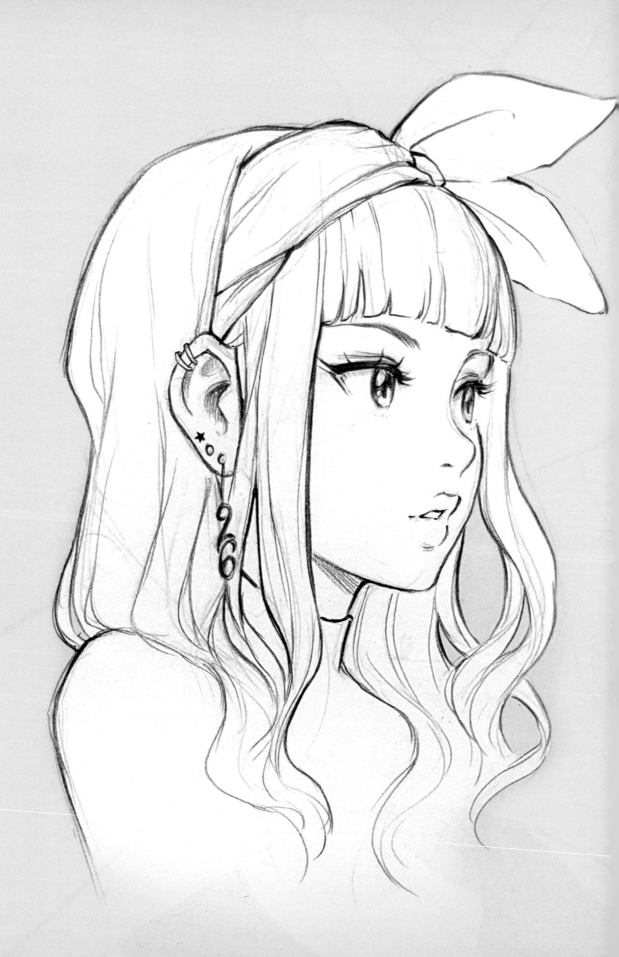

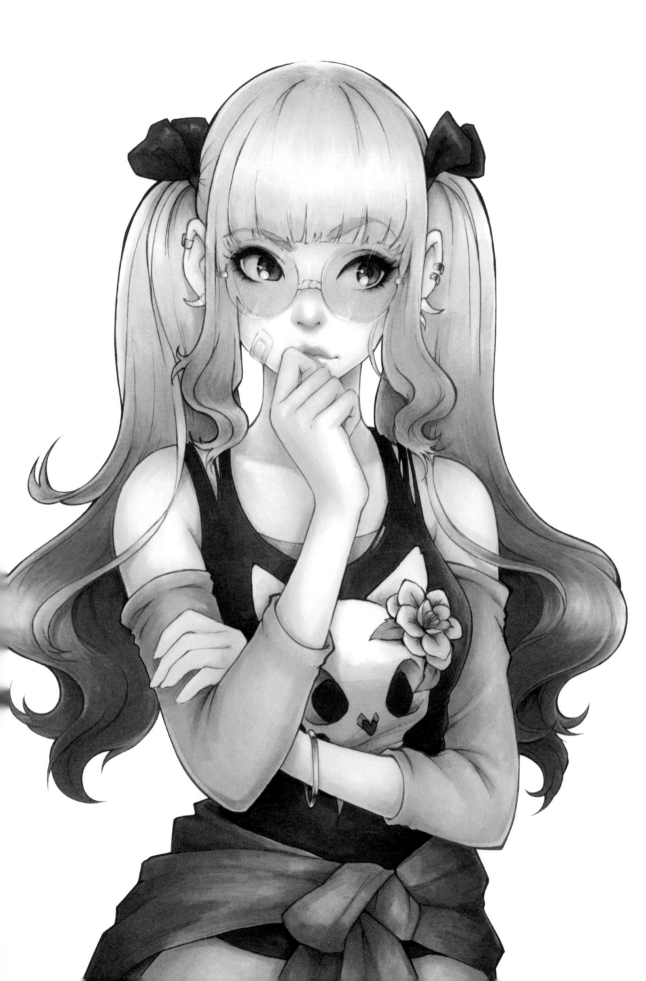

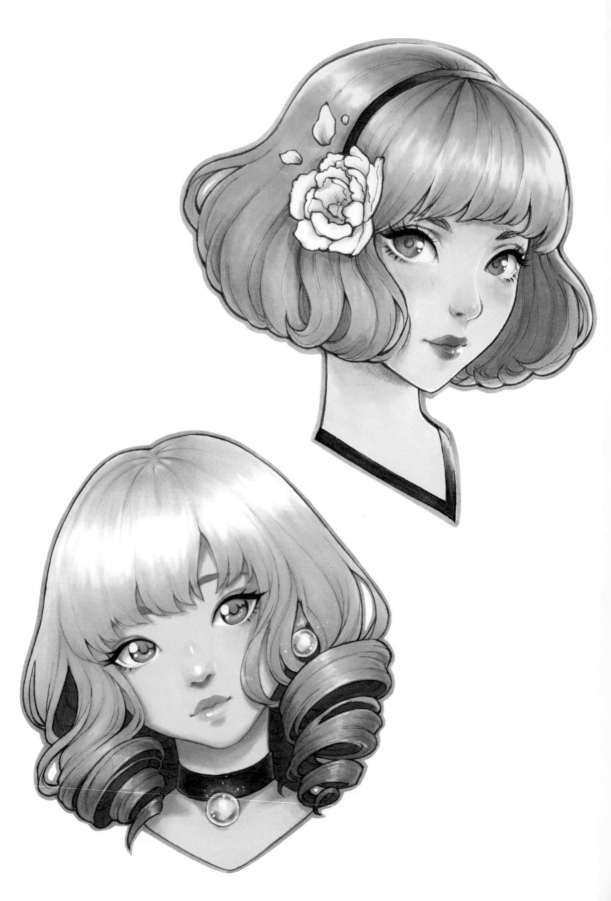

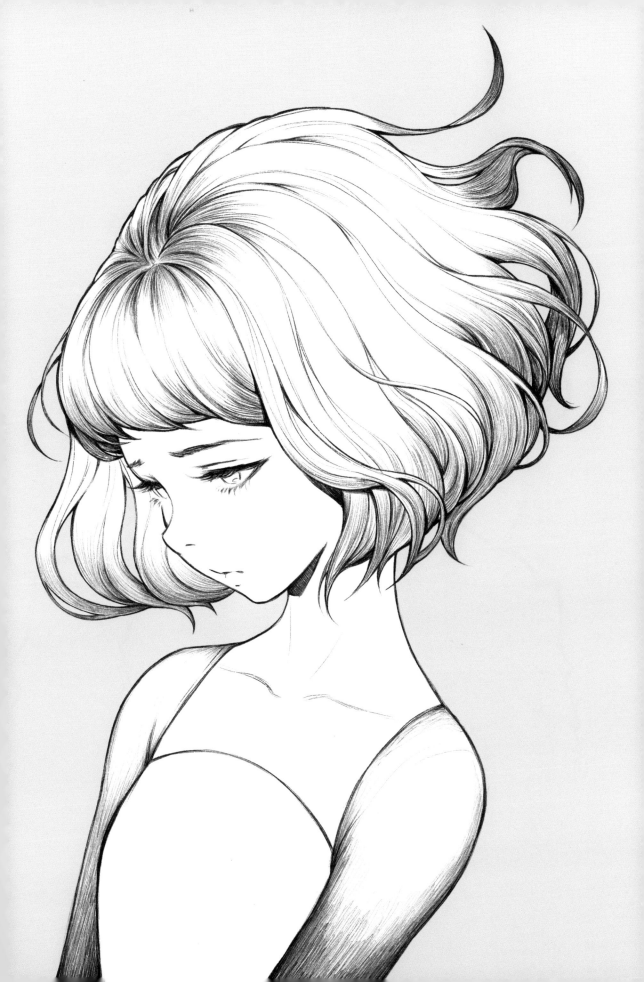

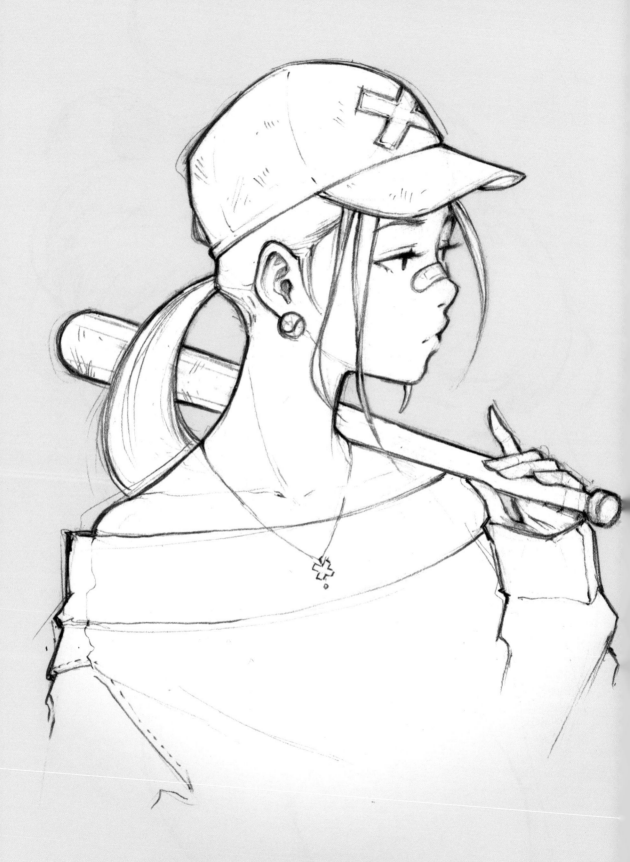

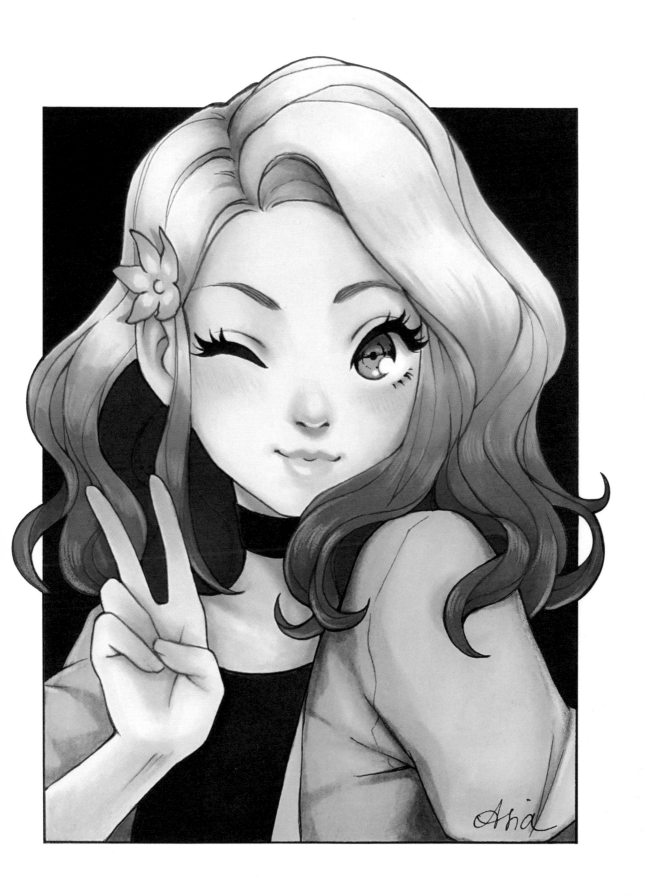

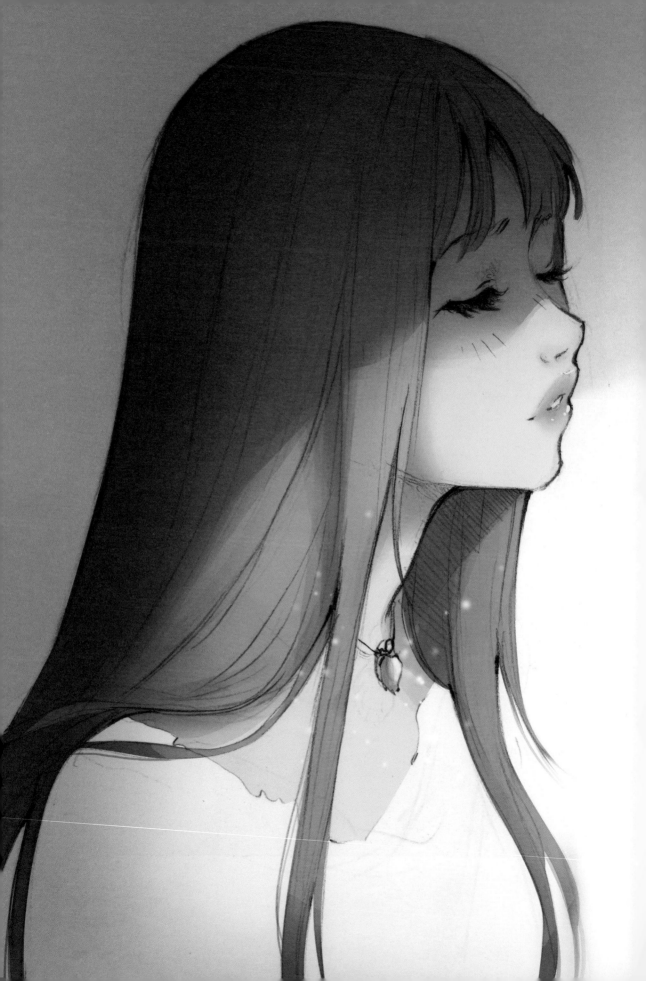

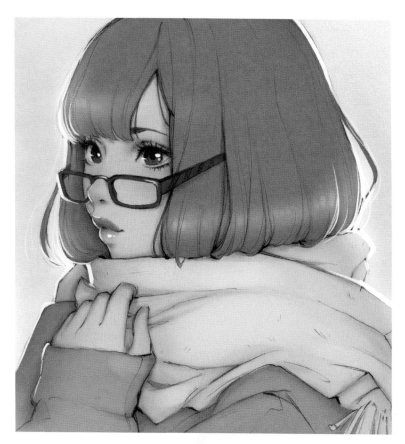

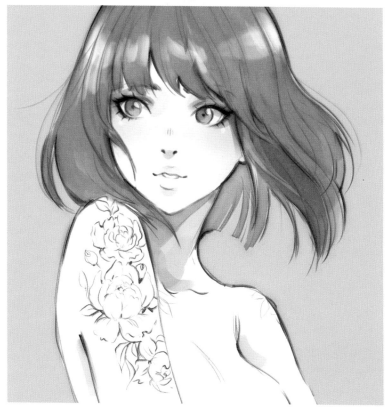

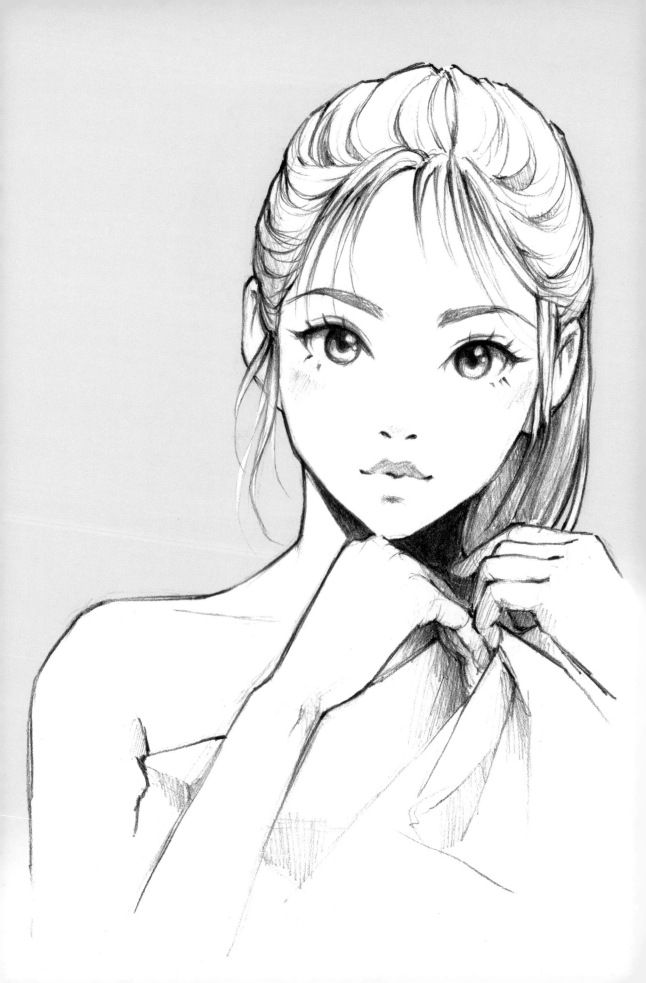

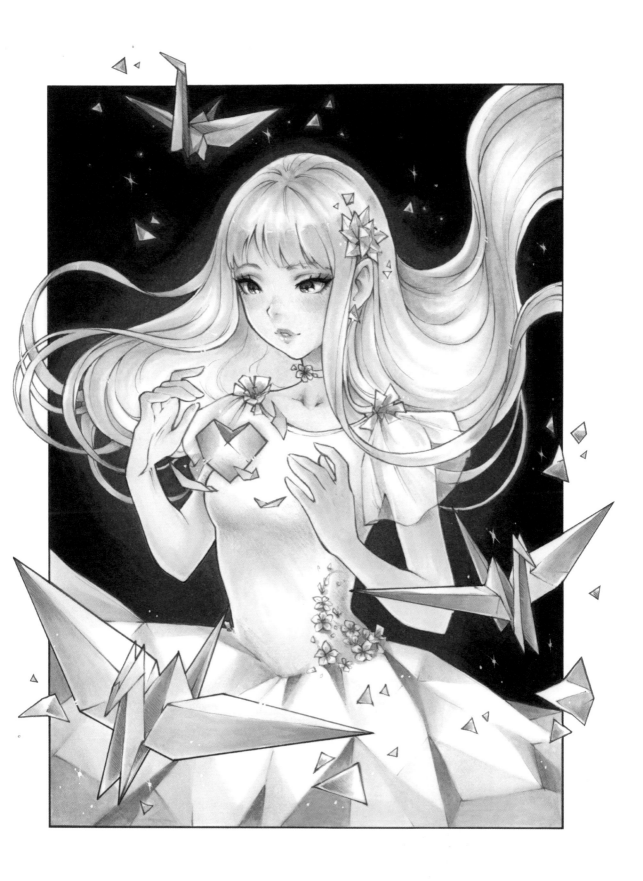

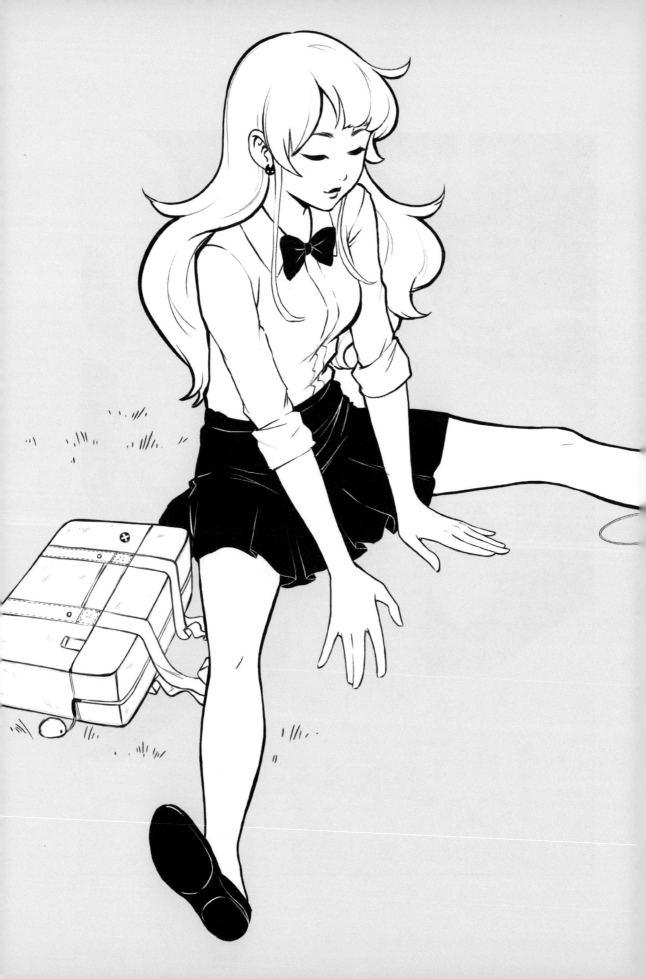

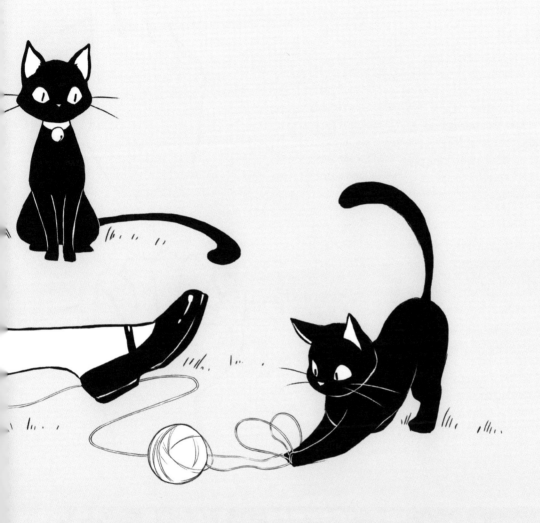

GETTING
STARTED

TOOLS

The most common questions I receive are about the tools and brands I use. But before I go into the specific tools that I choose to use, firstly I need to give huge credit to my hands! They have held many tools, been cut many times, and hurt from drawing for too long. They have learned how to work with any tools I decided to put in them, and even though I am attached to some brands, in the long run I always stress that with enough practice you can master any tool.

TABLET
I use a Wacom Cintiq 13" digital graphics tablet and I also have an iPad Pro, which allows me to practice more digital art on the go. I am still learning how to use them both!

COMPUTER
This was built by my husband and he made sure I can render really long high-quality videos on it! I have no idea how it does it, but it is fast!

COPIC MARKERS
I have managed to collect almost all the Copic marker colors apart from the green ones. For some reason, I forgot to buy them when I was in a shop where I could purchase them in Japan. Green is my least favorite color, so perhaps it wasn't just coincidence!

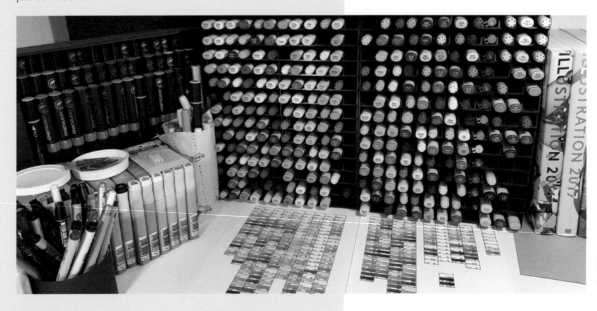

Sakura Pigma Micron pen, Black – 0.05 mm–0.1 mm

MULTILINERS / FINELINERS

I use various brands of inking pens. I still experiment with brush pens, but for standard thin lines I mainly use Copic Multiliners, Uni Pin fineliners, and Sakura Micron pens.

Copic Multiliner, Sepia – 0.05 mm–0.3 mm

Copic Multiliner, Black – 0.05 mm–0.3 mm

Uni Pin fineliner, Black – 0.05 mm–0.3 mm

Chameleon – Color Tones

CHAMELEON

Not long ago, I discovered these really amazing markers that are designed to create gradients and I love them! They create color transitions within one color as well as when combined with others.

Chameleon – Color Tops

COLORING PENCILS

I don't use coloring pencils on their own as much as I did a decade ago, but they complement Copic drawings perfectly. The ones I use came in a set with my Chameleon markers.

Mono eraser

Uni Nano Dia Color mechanical pencil leads – 0.5 mm

PAPER

I use Moleskine sketchbooks, printer paper for pencil sketches and studies, sticky notes for everything, and Canson Moulin du Roy hot-pressed watercolor paper for Copic drawings.

Moleskine sketchbook

Canson Moulin du Roy 300gsm

PLAIN PENCILS

Most of my pencils are mechanical and the reason why I use them isn't that they are necessarily the best or that they are of the brand I like, but they all have a sentimental value. I got one from my mother, one I brought from my first trip to Japan and a matching one I acquired on my second visit there, and one of them is from a friend at my old workplace. I can almost say that I "draw with my memories!"

To be more specific, I have pencils in various sizes (0.2, 0.35, 0.5, and 0.7 mm) and in various softnesses (HB, B, 2B, and 3B). I use Uni Nano Dia color leads for under sketches.

Opposite are a few examples of the pencils I use.

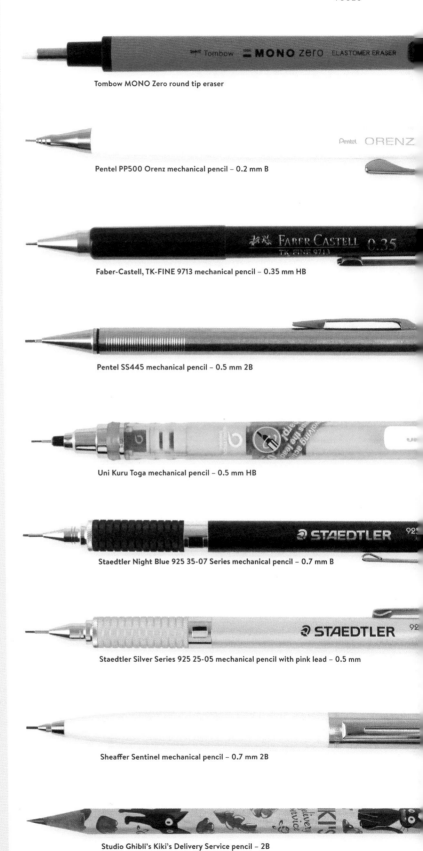

Tombow MONO Zero round tip eraser

Pentel PP500 Orenz mechanical pencil – 0.2 mm B

Faber-Castell, TK-FINE 9713 mechanical pencil – 0.35 mm HB

Pentel SS445 mechanical pencil – 0.5 mm 2B

Uni Kuru Toga mechanical pencil – 0.5 mm HB

Staedtler Night Blue 925 35-07 Series mechanical pencil – 0.7 mm B

Staedtler Silver Series 925 25-05 mechanical pencil with pink lead – 0.5 mm

Sheaffer Sentinel mechanical pencil – 0.7 mm 2B

Studio Ghibli's Kiki's Delivery Service pencil – 2B

SKETCHING

In my opinion, sketching is the most important – as well as the most enjoyable and rewarding – of all art techniques. I love the sense of freedom and freshness you get from sketching; sketches don't need to be perfect or finished. And, perhaps surprisingly, I find sketches can look more interesting than the final, polished design. They show the initial vision and construction integral to their design, which often gets lost in the finished version.

It helps to focus you if you have an initial idea to base your drawing on. Trying to produce something impressive first try, based on chance, is difficult and time-consuming. When I began to draw, I didn't realize the stifling power of my stubbornness while trying to get a design right the first time. Consequently, I often gave up on my sketches. I would try to draw something different, hoping it would miraculously look better, but this wasn't the case. Now I know that when I am struggling, the worst thing to do is to give up, and the best thing to do is to look for appropriate references and keep practicing. Perseverance is key – pushing out of your comfort zone in order to grow and develop your design skills.

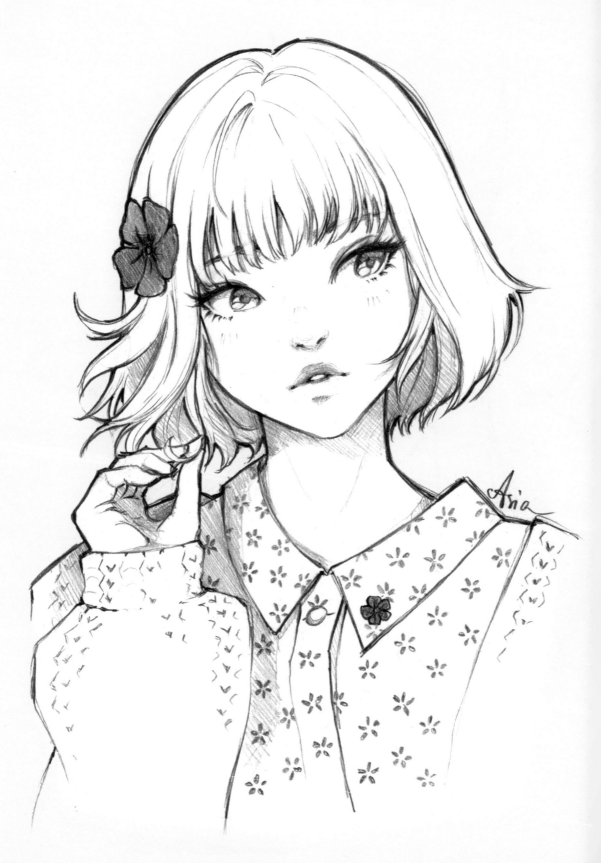

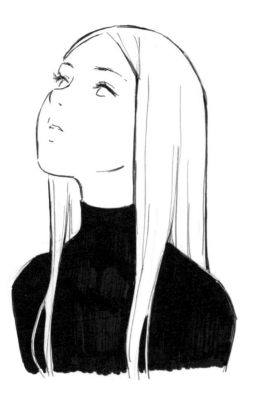

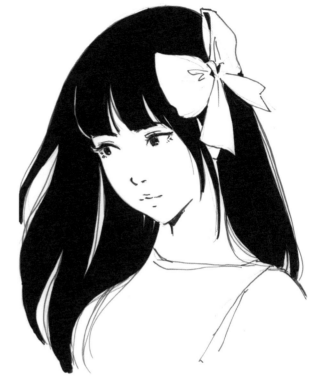

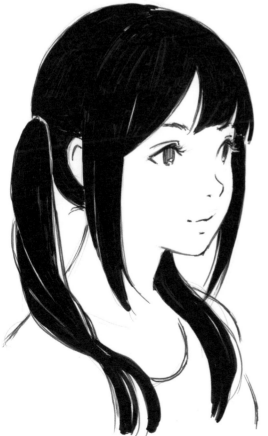

Sketching is something I can do no matter where I am. I always keep a sketchbook and something to draw with in my bag. I choose not to stare out the window when riding on the train or while sipping coffee in the coffee shop; instead I draw. I started my drawing adventure just doodling for thirty minutes before work, and this taught me that every moment is precious. Using additional minutes here and there throughout the day adds up over time – the minutes turning into hours of drawing practice. There is also endless inspiration around you waiting to be studied and drawn.

It doesn't matter how much time you put into each sketch. Sometimes a few minutes are enough and sometimes a sketch develops into something unexpected, so spending hours on it is justifiable.

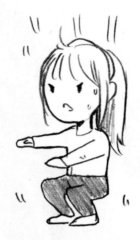

WARM-UP SKETCHING

A useful type of sketching, that I often begin with, is warm-up sketching. I create warm-up sketches before starting any drawing – including studies, full illustrations, and even before continuing something I had started in a previous session. I allow my warm-up sketching to be as free and relaxed as possible, and give myself a time limit for this type of sketching. Warming up helps the hands feel comfortable and tests the pressure of the pencil. I often undertake a quick exercise of flat shading in squares using different pencils to prepare for the sketches, too.

I tell myself that I am just warming up because knowing that these drawings are destined for the bin takes the pressure off! Before I discovered the power of warm-up doodles, I often found drawing stressful and I couldn't understand why my drawings looked uninteresting and stiff. It was a relief when I saw how various artists used "warm-up sketching" as a stage in the drawing process where it was okay to make mistakes. Half an hour of warming up – even if it is just swirls and zigzags – can get you in the mood for drawing and if it doesn't, it may be a sign to do something else that day. I might choose to do some photography or video editing, for example.

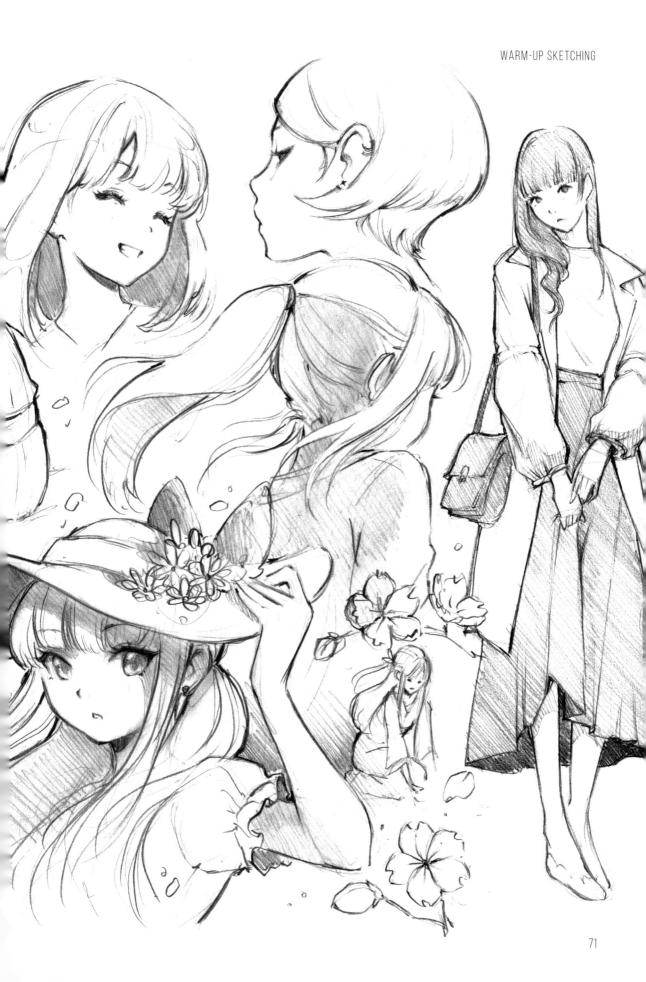

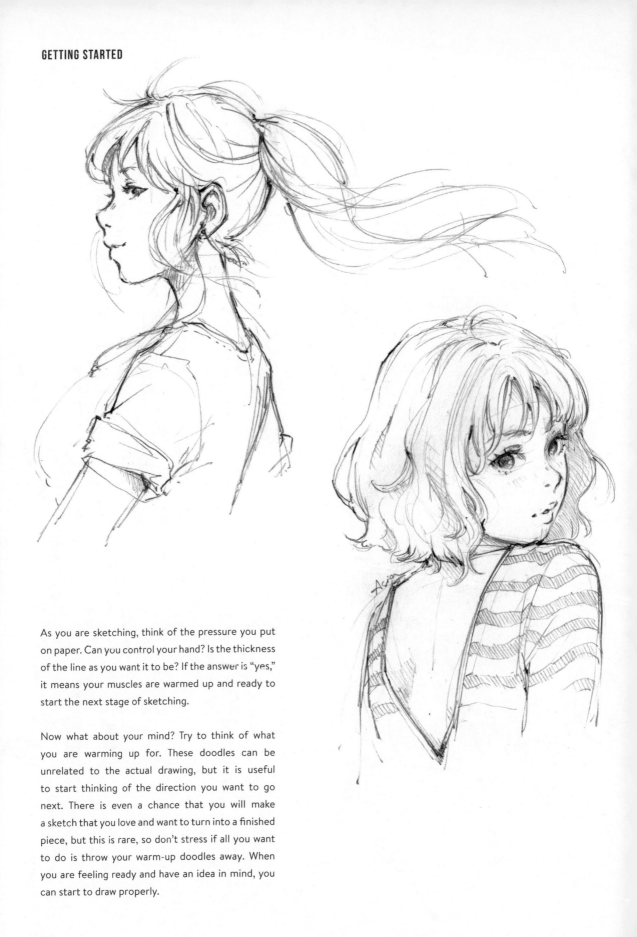

As you are sketching, think of the pressure you put on paper. Can you control your hand? Is the thickness of the line as you want it to be? If the answer is "yes," it means your muscles are warmed up and ready to start the next stage of sketching.

Now what about your mind? Try to think of what you are warming up for. These doodles can be unrelated to the actual drawing, but it is useful to start thinking of the direction you want to go next. There is even a chance that you will make a sketch that you love and want to turn into a finished piece, but this is rare, so don't stress if all you want to do is throw your warm-up doodles away. When you are feeling ready and have an idea in mind, you can start to draw properly.

HERE ARE SOME TIPS TO HELP YOU GET STARTED:

DO:

- Keep your warm ups quick, fresh, and sketchy.

- Draw anything: a circle, your own hand holding a pencil...

- Spend thirty minutes to an hour warming up.

- Keep your warm ups small, even sticky-note sized. Quantity is what really helps!

- Focus on the full object and flow of the lines.

DON'T:

- Overwork your warm ups!

- Waste time thinking about what to draw.

- Spend more than fifteen minutes on a sketch.

- Make your warm-up sketches too big.

- Focus on small details.

THUMBNAIL SKETCHING

Before creating sketches for an illustration, I imagine the concept. I close my eyes and imagine the finished scene or character and then draw a tiny sketch of the composition – these are called thumbnail sketches. If the process is digital, I zoom out of the canvas and use a wide brush, making sure I don't add too much detail. Creating thumbnail sketches helps to focus on composition and the initial stages of the idea. I usually create a few variations of the design, keeping them just a few centimeters in size.

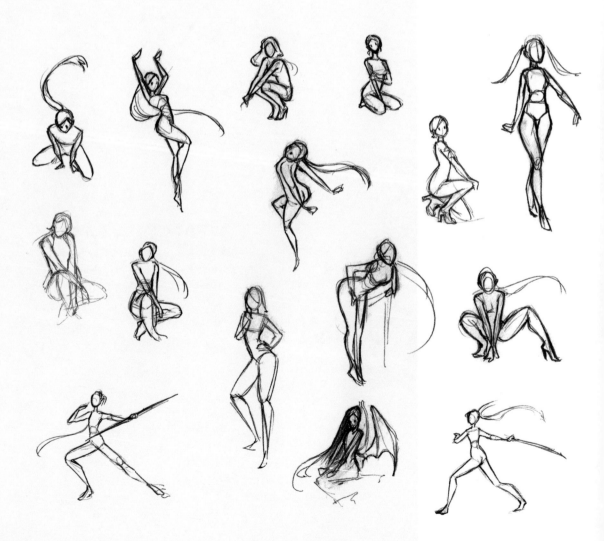

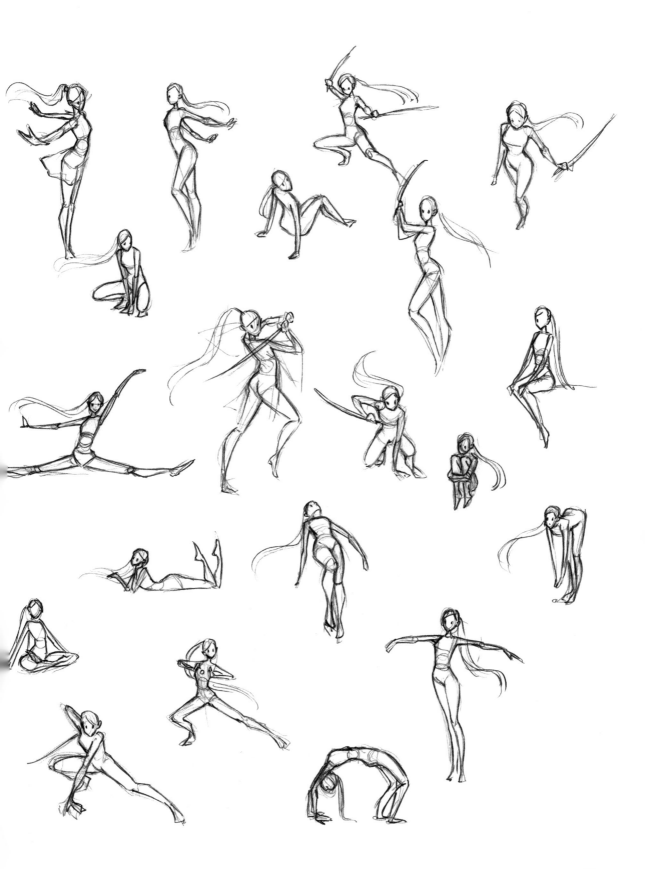

CONCEPT SKETCHING

For each of my designs I make many concept sketches, each one serving a different purpose. Some are thumbnail sized as discussed on page 70 and others are larger, but they are created to record an idea, like a note to stop me forgetting something. These sketches are often drawn from my imagination – very messy and only readable to me. They may look like meaningless lines to other people but when I see them I can quickly recall what the idea in my head looked like. I can then use these sketches to form the basis of a more finished design, as shown in the progress images here.

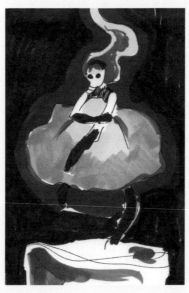

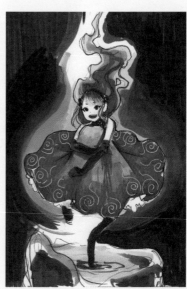

OBSERVATIONAL SKETCHING

Another type of sketching I use extensively is studying from a reference, but it is an area I feel I need to improve on. I often create a lot of sketches of the same element, such as hands, muscles, or a certain pose. There is no better way of learning to draw form than studying by repetition. This is something I learned from Warren Louw. After sharing with him my frustrations of being unable to draw something, he asked me how many times I had drawn it before, and when I realized the answer was *never*, I understood my biggest mistake: trying to get things right first time. Drawing is a skill like any other, and it needs to be practiced. I remember drawing the hands of my fellow class members during our Japanese language study group. I realized that my abilities to observe and quickly sketch from life had rapidly improved because the "models" kept changing their positions and I had no other choice but to keep up!

SKETCHING MISTAKES AND HOW TO AVOID THEM

It is a good idea to learn how to make sketching techniques effective by avoiding common mistakes. Without a good sketch you can't achieve great final results and I believe sketching is the most important part of drawing.

I hope this guide helps you to pay more attention to some of the most common mistakes and learn how to avoid them in the future. It is more about being aware of what you are doing rather than getting it right first time. Remember to practice and use your time wisely.

MISTAKE 1: AVOIDING CONSTRUCTION AND NOT VARYING LINES

It is a good idea to begin a sketch with construction lines, but if you avoid them or use the same line weight throughout it is not effective. Some people just want to finish their drawing and don't vary the pressure of their chosen tool, they just focus on keeping the pressure consistent, and often too hard. This results in lines that have one thickness and darkness, making the drawing feel very stiff with the mistakes standing out. Because the drawing is so "clean", and has a lack of construction, it is difficult to focus on the full picture.

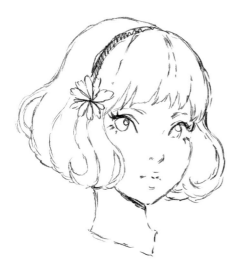

MISTAKE 2: OVERTHINKING LINES

This is similar to the previous mistake; being too precious about your lines. Again, there is no construction. This can happen when you are concentrating too hard on the reference image. Copying something with strong lines, such as an anime face, can mean that you focus on copying each line accurately, but when you lack the confidence to create bold lines, a weak hair-line effect is created instead. To avoid this and create a more structured image, be confident when placing a line and do not repeat it in one place.

MISTAKE 3: STARTING WITH THE SMALLEST DETAILS AND INEFFECTIVE SHADING

Sketching the smallest details first, like an eye for example, is a very common mistake, even for professional artists. It is something you can do effectively once you are more experienced but is difficult to master. Again, there is no construction or feel for the full image here. With sketching you should be free to construct the basic shape then add more forms and details later. Starting with detail first will dictate the overall finish. Also, shading with cross-hatching using a pencil and drawing lines in different directions can produce bad results, so make sure all lines are drawn in the same direction.

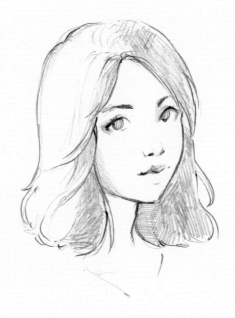

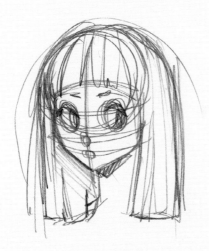

MISTAKE 4: SKETCHING TOO MANY LINES

Another common mistake is creating too many lines using the wrong tool. Also, similar to not varying the lines (as with mistake 1), it is not good practice to make the construction lines too heavy.

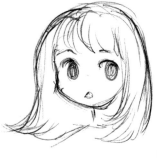

MISTAKE 5: MAKING LINES TOO STRAIGHT OR TOO ROUNDED

This mistake, again, can be made by not controlling your lines. This can work if you are an experienced illustrator, but it will ruin your drawings if you are not good at it. If you focus on your lines too much and make them too straight or too curvy, it doesn't create a perfect balance for your drawing. This can work with certain elements and objects, like using only straight lines for architecture, for example, but for character designs you should diversify lines and make them smooth and rounded where they should be and straight where they should be.

MISTAKE 6: STARTING WITH A LARGE PAGE

An extremely common mistake to make is working on a format that is too large. Not being able to see the full drawing properly close-up can affect the overall design. Large formats also force us to add more and more details to fill in the page, but smaller scale drawings stop us from getting lost in them. The proportions will also be more accurate as features are clearer in a smaller format. I recommend new artists sketch on A5 paper or smaller, and work their way up to a larger format one step at a time.

SAMPLE SKETCH

It takes self-awareness, motivation, and lots of practice to develop drawing skills. Instead of waiting for a large chunk of free time to attempt to develop your skills, make the most of small snippets of time to practice your sketching techniques.

This final sketch took me just twenty minutes. I worked in a comfortably-sized format, creating light construction lines with a pink lead pencil. I have also added shading, keeping the lines in the same direction. The next step was strengthening the outline, and for this I used a darker pencil. At the end I get a result with diversified lines.

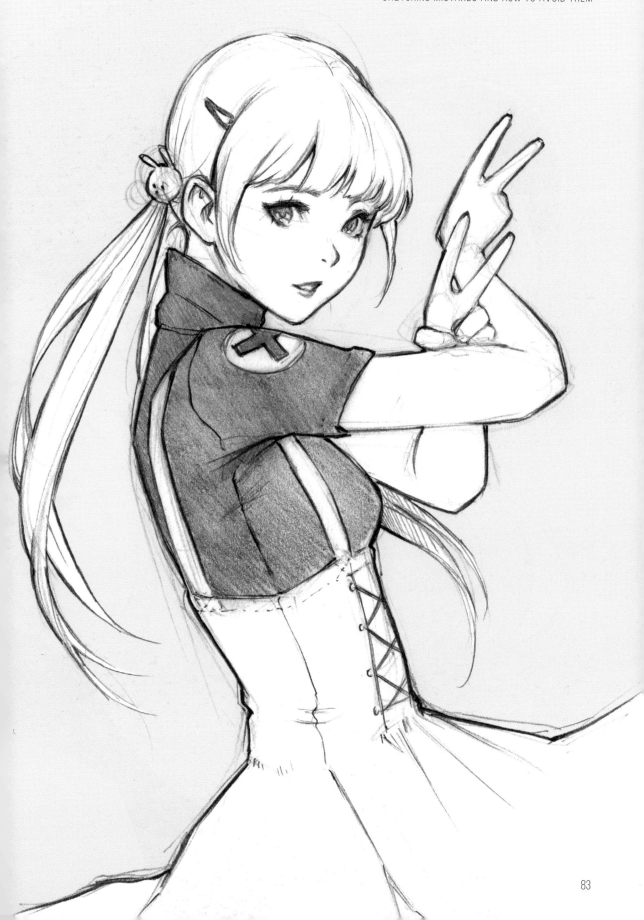

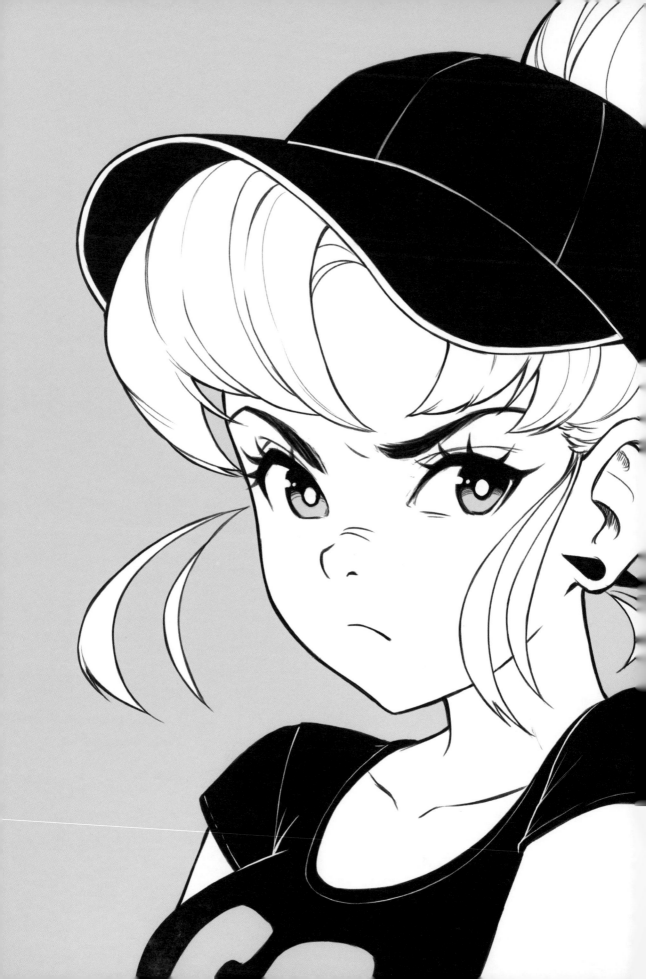

TECHNIQUES
AND ADVICE

FACES AND FEATURES

Drawing a face is a simple process. However, drawing a face for the *first* time can be very daunting and not so straightforward. In this chapter I will outline the principles of drawing a face and how you can use these to design your own stylized characters. If you practice this regularly, I promise that a face will become one of the easiest things for you to draw!

You are probably already aware of the most commonly used method to construct a face: first, you draw a circle, followed by a vertical line down the center, and two additional horizontal lines to indicate the placement of eyes, nose, and mouth. The proportions of these vary depending on the style of face you

are drawing. For example with a manga-style face the eyes are oversized and detailed, and the nose and mouth are small and simple. While beginning to design a face and head with this method is effective, and we will use it as a foundation for our designs in this guide, there is more to it than this.

It is important to *understand* the underlying construction of the head and face, rather than just drawing a circle and a couple of lines, and only producing a head facing forward. In this chapter I would like to emphasize the importance of observation, understanding, and stylization when creating characters.

BASIC METHOD

If you haven't heard of the basic method before, here is an overview. Feel free to follow these basic steps to familiarize yourself with how to construct a head and face in a simplified way. This will provide you with a foundation from which you can follow the rest of the chapter, in which we will add life and soul to our characters.

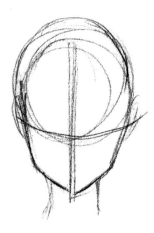

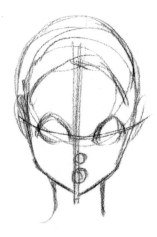

1. Construct the basic shape: a circle with a triangular jaw line below it, a straight vertical line down the center, and a horizontal arc to help you define the position of the eyes.

2. Block out space for the eyes (I find almond shapes perfect for that), nose, and mouth with a few circles. The eyes should intersect the horizontal arc you drew in step 1 and the nose and mouth should appear in the lower sector and follow the vertical line.

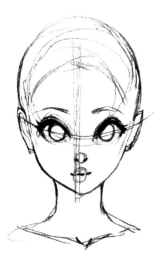

3. Give the eyes, nose, and mouth a more defined shape, and add eyebrows. To see if it looks right, I flip the page around and look at it against the light. There will be more examples regarding shapes and sizes of elements further on in this chapter.

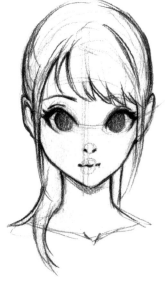

4. Sketch in a hairstyle and erase strong construction lines a little. The chapter on drawing hair (pages 102–109) gives ideas on how to create different styles.

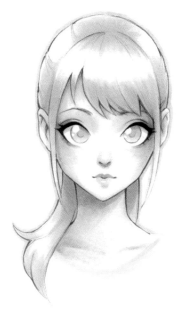

5. You can then copy the sketch onto a higher-quality paper, and ink and color it.

If we just follow these steps without really thinking about what it is we are drawing, our sketches will lack dynamism. On the next few pages we will look at how we can expand on and go beyond each of these steps, starting with observation and warming up, to create faces in an intuitive way.

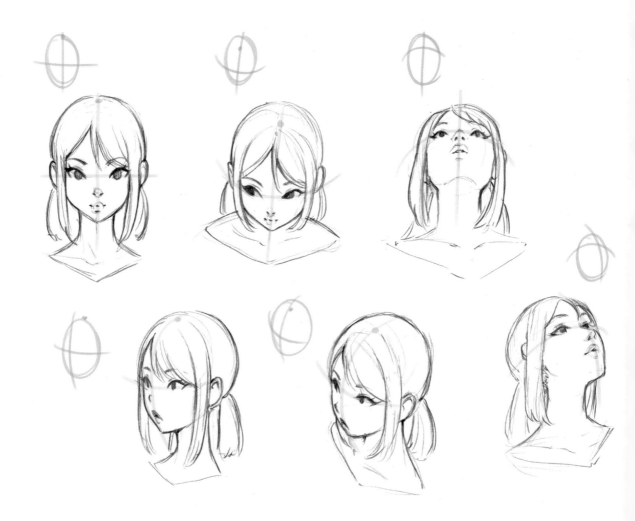

OBSERVE, UNDERSTAND, STUDY

It is good to just observe people around you before starting a drawing, and even better to do quick portrait sketches of them if you can. You can use the steps on the previous page as a starting point but make sure you draw what you see, in whatever style it turns out to be. Take in the variety of face shapes and the finer details of each feature to build a style you are more driven toward.

You see faces everywhere, every day, but when you see them, do you stop and think, "What shapes do they resemble the most? What do they consist of? Where do the shadows lie? What are the relationships between the elements: the lines, angles, distances, lengths, and sizes?"

You won't determine all of the answers to those questions when drawing something or someone for the first time, but if you start looking around in this conscious manner more often, it will have a positive effect on all your future drawings. Knowledge builds confidence.

"KNOWLEDGE BUILDS CONFIDENCE"

WARM UP

To warm up, try sketching from real-life references, but if this is not possible you could also just draw doodles from your mental bank of visual knowledge or imagination. If I am feeling unmotivated or low on creativity, sometimes I open a fashion magazine at a random page and pick up some ideas for quick head sketches. Using fashion images for inspiration also gives the sketches more energy and variety and helps you to prepare for drawing more dynamic heads and faces. Remember, it is fine to keep warm ups quick and messy; don't overspend time on them.

CONSTRUCT YOUR DRAWING

Now we have finally come to the "draw a circle and a line" stage! But if you followed the previous steps and did your warm ups, the shape you start with will have a different meaning for you. Now, the circle is not just a circle that someone told you to draw, but it is the shape that you defined yourself, which resembles the object that you are drawing. You can now lay a more effective base for your drawing with an oval shape, a collection of circles and triangles, or whichever shapes you require.

In most cases the head can be simplified to a deformed sphere that looks like a circle or oval when depicted flat. Considering the circle as a head, it becomes more dimensional and it is apparent that more than just a flat circle is needed. You can construct these elements on paper by using the knowledge you have gained from previous study and observation work to inform your design decisions.

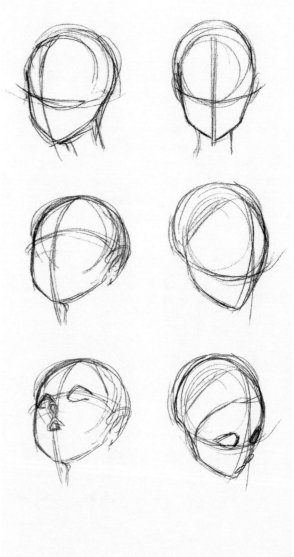

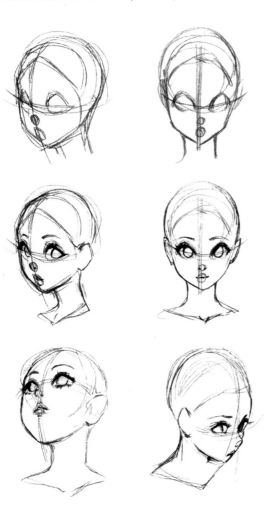

ADDING FEATURES

With an effectively blocked-in base, we only need to add some loose details to indicate the key features, while keeping that depth of form, to create a strong sketch. After placing the eyes, nose, ears, and mouth in the correct positions you can then determine where the hairline would lie and begin to define the features. Make sure to consider the direction the head is pointed in and the placement of the eyes, nose, and mouth.

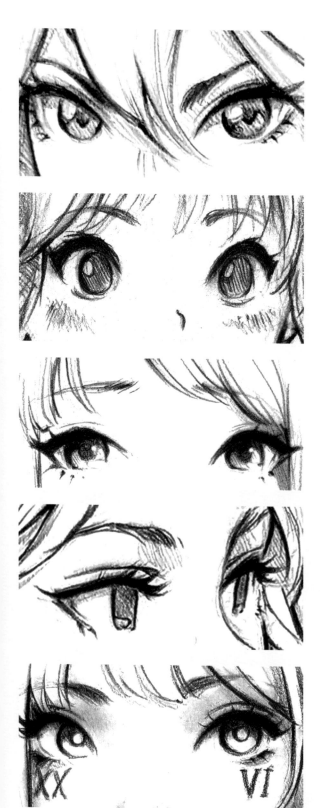

DEFINE THE DETAILS

Now you can wipe the sweat from your forehead, because it is an easy road ahead! This stage is a lot of fun, if you allow yourself some freedom. Based on the construction from the previous step, add more details to refine the shapes, styles, and sizes of each element. For example, I might add further detail to the eyes and eyelashes, and give the hair more definition. But how do I do it? Where do all these shapes come from?

These shapes come with experience – from warm ups, practice, and experimentation. My visual library is packed full of different ideas for face and head designs that I have stored from previous drawing sessions, but for you to build your own visual library it is important to play around with styles and variations, making sure to draw many different versions.

If you are unsure of where or how to start, you can always copy my drawings first. I would encourage you to develop your own style and way of drawing these elements eventually, but to be able to do this, practice and a lot of experimentation is necessary.

EXPERIMENT

A final, key piece of advice is to remember to experiment! Have fun with shapes, sizes, and proportions of all the facial features. As the designs are intended to be stylized, there is no right or wrong way of drawing them. You need to experiment to develop your own personal style and your limitations are just the ones you set yourself. You could try different styles of eye shape, differing levels of details and accuracy to real life, and a variety of moods, emotions, or tones you wish to convey. You can see some examples of my experiments pictured on the following pages. When working on a head design, I create many different versions to decide where I want to take the drawing next.

This freeing experimental stage is important because many of us are scared of experimenting in case we make mistakes or develop designs that don't work and stop our momentum. We are also held back by our knowledge of what we think works and put ourselves off trying something new because we are unsure of the results.

Experimenting like this can also be a bit of an overwhelming process, as there are infinite possibilities and subtle variations to play with. And sometimes the results do look bad, but sometimes I draw something that I am certain will look unappealing, and it ends up being my favorite sketch. This shows that happy accidents do happen, and that drawings belong on paper, and not in a head full of false assumptions.

Experimenting is ultimately extremely beneficial to your creative work, if you give yourself the freedom and space to make mistakes and learn from them. It is part of the invaluable gathering of knowledge; knowledge that will inform your future creations.

Armed with a basic understanding of the anatomy of a head and face, you can go on to push the boundaries of what your drawing can achieve and the finishes you can create.

Experimentation is so much fun. It can lead you to discover some of your favorite work, and may even help you to mold your own style of drawing! As with any drawing, once you understand the basic fundamentals of an object and how it behaves, you can simply improve with practice. I encourage everyone to study and experiment. No first drawing is ever perfect, and if you think it is, draw ten more versions and you will see that it wasn't!

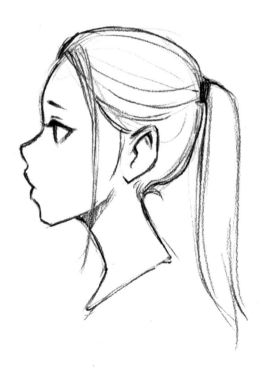

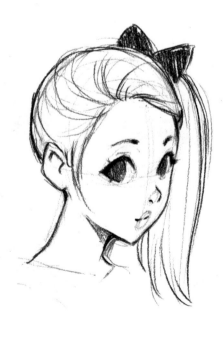

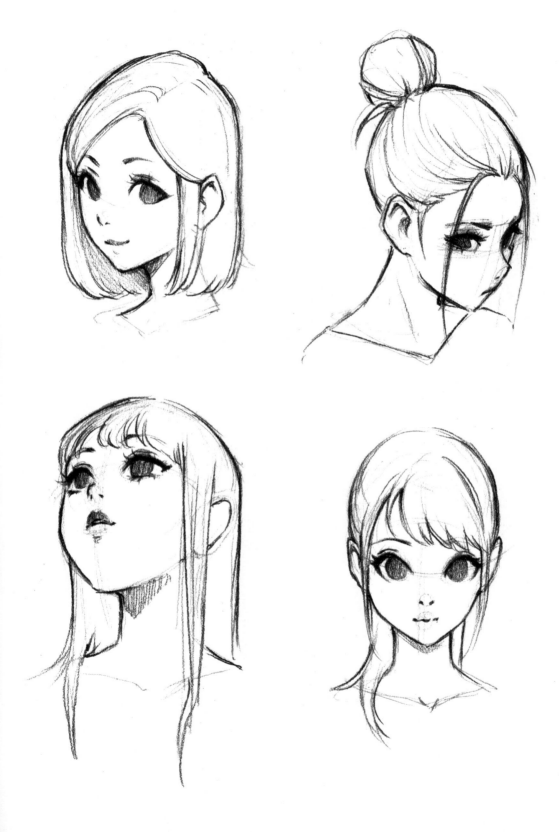

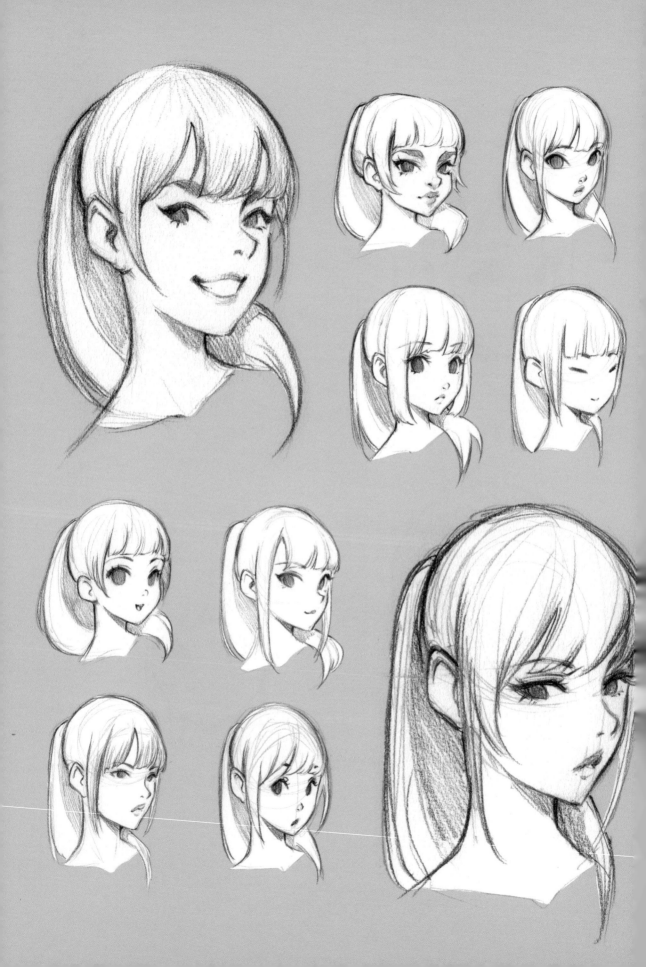

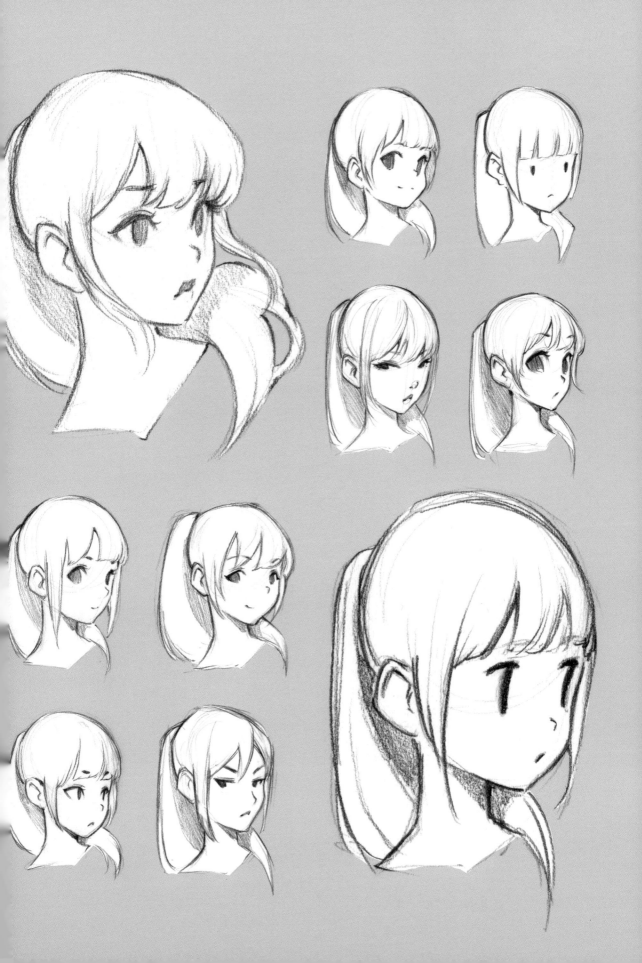

EXPRESSIONS

Expressions are my favorite thing to draw! There is so much fun and observation involved. An expression transforms a character, giving them feelings and emotion.

There are many methods you can use, and the amount of hints you put into an expression determines how strong and easily readable the result will be.

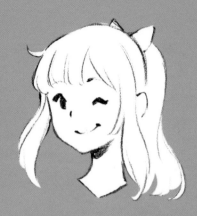

MOUTH AND EYEBROWS

The least we can do to change a facial expression would be to change the shape and positioning of the mouth and eyebrows – as simple as that. Look at the pictures to the right. Even though there are only mouths and eyebrows there, we can identify the expression straight away.

This is an important thing to notice and extract when observing real-life people and drawings of others that inspire us, but **this is not everything**. There is so much more that can build an expression other than the mouth and eyebrows.

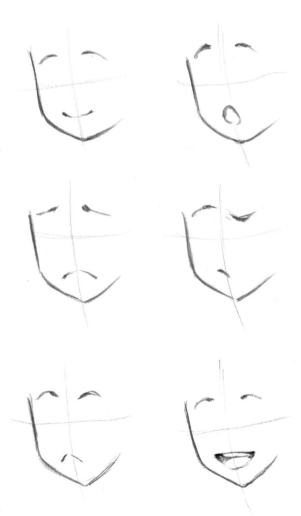

INCORPORATING OTHER FEATURES

Some other elements you could consider playing around with to create expressions are:

EYES – their size, the size of the pupil, their angle and shape. Eyes alone can tell a tale!

LINES AND SHAPES – the flow of the lines and rounded or angled shapes suggest different feelings.

HAIR AND ACCESSORIES – you can use creative license to add life to the hair and accessories to assist with the expression.

HEAD ANGLE – if a person is feeling sad, for example, they tend to tilt their head down; and while feeling confident and happy, they hold their head high. When someone is angry they look at you from below their eyebrows with their head tilted down.

SHOULDERS – you can include the shoulders when drawing a portrait – they are a small but expressive part of the body. Body language alone can suggest a lot about a character's mood.

TIP: All elements of an expression like the hair, shape of the accessories, flow of the lines, and angles should complement the basic facial expression.

EXAMPLES OF HOW TO EMPHASIZE BASIC EXPRESSIONS

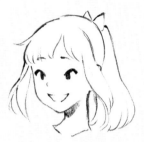

HAPPY

In this simple example, the slight movement in the hair lifts the mood and the happiness is radiating. The full shape of the bow is like a flower in bloom!

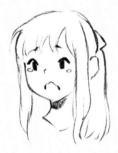

SAD

In contrast, in this expression all the lines are pointing downward. This is the case with all the lines, not just the mouth and eyebrows. The hair adds to the sad mood. So sad, that even the ribbon in her hair looks downbeat, unwilling to stand proud.

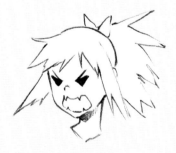

FURIOUS

This girl doesn't just look cross here, she looks furious! The expression is emphasized by the appropriate shape of the mouth, which is exaggerated by sharp teeth to make her look like an angry cat, but also by simplified eyes and spiky hair. The sharp, pointy shapes underline the intensity of this expression.

DEVELOPING INTENSITY

You can alter the intensity of some expressions by adding or removing elements. Here are some examples of different stages of three basic expressions:

HAPPY

A happy expression is always accompanied by a smile. The wider the mouth is open, the happier the character looks. The happiness intensifies with the lifting of the character's head and shoulders.

The hair flows to indicate movement and show that the girl is laughing. Where the eyes are open, you could draw larger pupils, as apparently when people are happy their pupils are bigger. This may be why happy characters look more natural with bigger eyes.

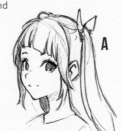 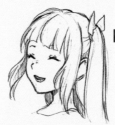 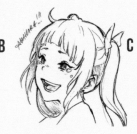

SAD

Drawing a sad character is about more than just adding tears to each stage; it is also about a special mouth expression. When crying, the mouth opens naturally so we can breathe through it and cry loudly, but we also try to keep them shut to stay quiet. This forces the mouth to look a little like a squashed "8." Eyebrows lift up with this expression, but not in a tension-free manner; they also look forced. The eyes naturally get narrower as the character becomes progressively sadder.

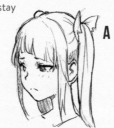 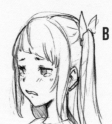 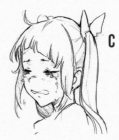

ANGRY

The stages of anger here are shown with slight tilts of the head and movement in the shoulders (as with the happy expression). This time, the head moves down as the shoulders go up. In picture C, where the character is releasing the anger, some tension from the shoulders is dropped but there is more movement involved elsewhere. I like to depict angry and moody expressions with a simple shape of the mouth that looks like an inverted "V." The eyes are smaller here because both eyebrows and the wrinkled nose are making them squint. Also, angry eyes are sharper and more angled than happy eyes.

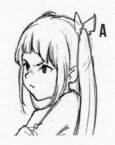 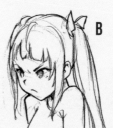 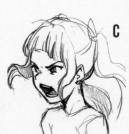

ADDING COLOR

What else can we use to add further depth to the emotion expressed? The answer is: color.

We tend to naturally associate certain tones with feelings. For example, pale blue and gray tones can suggest fear; green can suggest the character looks unwell and perhaps tired; red shows embarrassment or anger; and warm yellow makes a character seem positive and happy. Combining appropriate colors with the elements we have looked at already makes the expression clear, even at a quick glance.

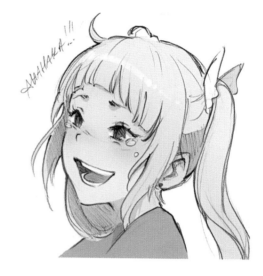

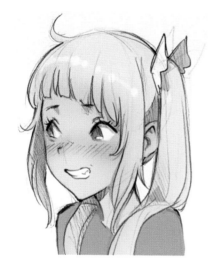

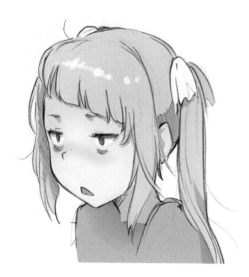

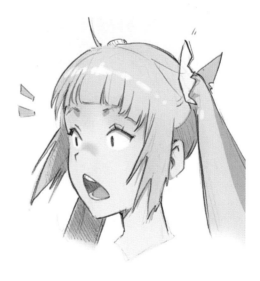

Why not have a go yourself at creating some different expressions, playing around with all the elements? Have fun!

HANDS

This chapter offers advice and approaches that I find useful when it comes to drawing hands. When I was drawing hyperrealistic work, I would spend hours building up a design that was based entirely on a reference. When the finished article looked just like my reference image, I believed I could draw anything. Although I created effective drawings, I did not learn anything about constructing my own designs because I didn't understand the fundamentals and construction. I didn't concentrate on creating the correct proportions, how light would affect the object, or the underlying anatomy. What I did learn from my hyperrealistic work, however, is that it is better to draw a thousand unpolished sketches than to overwork one drawing for a long time, because it provides you with invaluable knowledge and understanding of structure and fundamentals.

SKETCHING TECHNIQUE

When drawing hands, I aim to create very delicate designs, so I use a hard HB pencil to provide light construction lines and a soft dark B or 2B pencil for the final outline and any darker details. Some of my hand drawings are based on references and some are drawn from my imagination and memory. I will often use my left hand for reference while I draw with my right.

To add areas of shadow and give the hand some depth, I define where the shadows will be by adding delicate and light line shading with my HB pencil.

To develop your own style and enable you to feel comfortable drawing hands, practice is very important as it will help you to understand the overall shape and construction of a hand. The more you practice, the more you will improve!

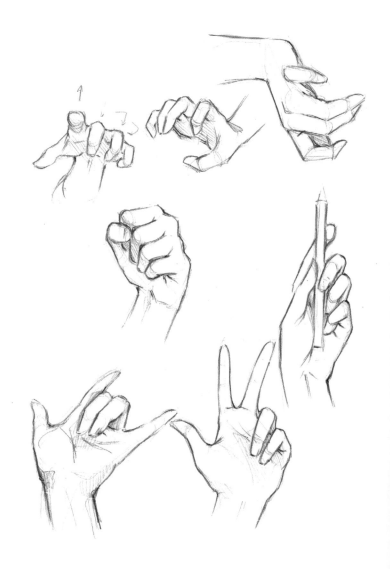

WARM UPS

One of the most useful techniques for sketching anything is to start with simplified shapes. To start a hand I draw a square shape with the fingers made up of rectangles and sometimes triangles. Breaking the form you want to achieve down into simplified shapes makes it easier to understand the construction. Warm-up sketches like these relax your hand and give your future drawings more energy.

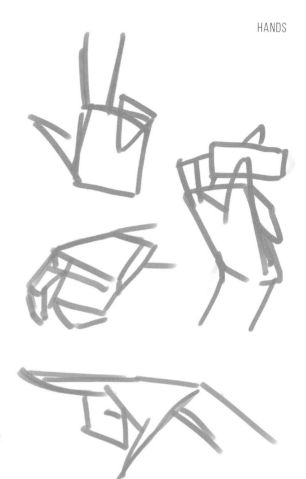

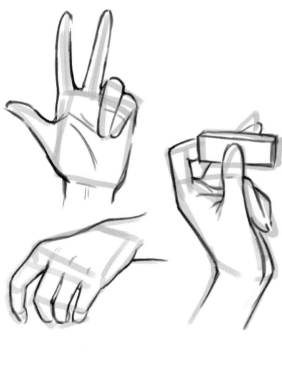

OUTLINE

After warming up and practicing creating hands using block shapes, the next step is to establish the outline of the hand. The outline of the back and the palm of the hand can sometimes be the same; it is the finer details that will distinguish the back or the palm.

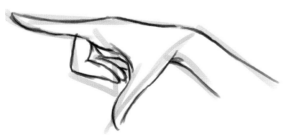

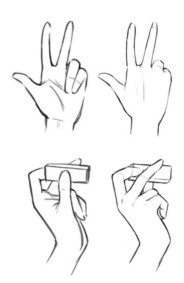

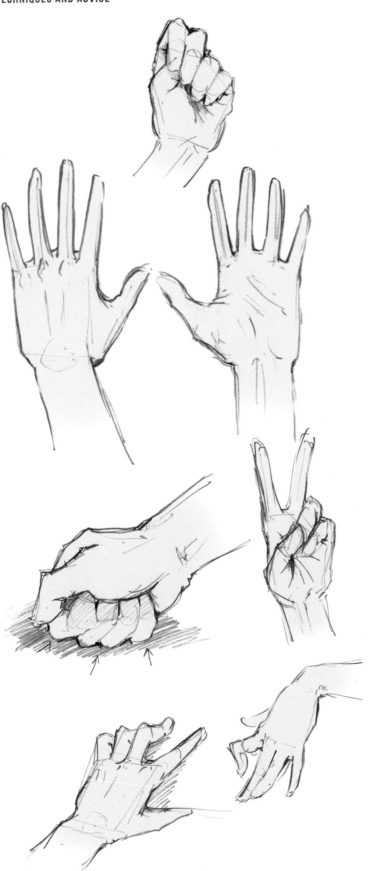

ADDING DEFINITION TO THE FINGERS

When drawing the fingers, you need to keep in mind that they are not all the same length. Also, fingers don't all start from the same position on the hand. The longest finger is the middle finger, which also starts at the top of the arc of the palm of the hand. The second longest finger is the ring finger, followed by the index finger, then the little finger (the fourth in the row), and lastly the thumb. The thumb is not only the shortest of the five, but it also comes off the palm of the hand in a completely different direction.

When drawing the back of the hand flat, you will also need to consider the placement of the fingernails – the thumbnail will need to be drawn slightly from the side. To indicate fingernails in my drawings I often end fingers with angular shapes, rather than making them oval. In general, I don't like adding fingernails to my drawings as I think they give the hand harshness and can distract the viewer from the rest of the drawing.

To construct the fingers, it is helpful to start with an arc and draw the fingers fanning out slightly from the palm of the hand. It is also important to remember that fingers are not completely straight, so make sure to study your hands in depth when drawing!

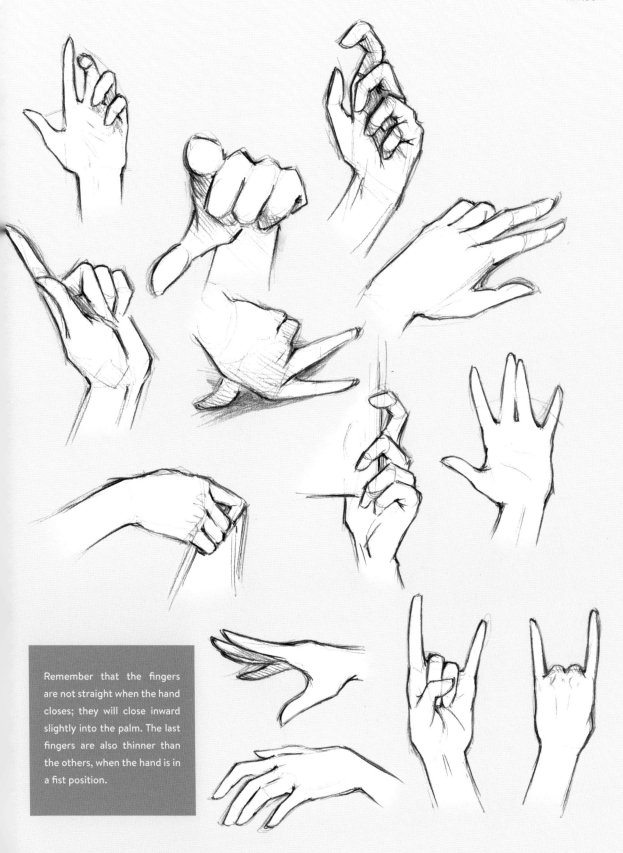

Remember that the fingers are not straight when the hand closes; they will close inward slightly into the palm. The last fingers are also thinner than the others, when the hand is in a fist position.

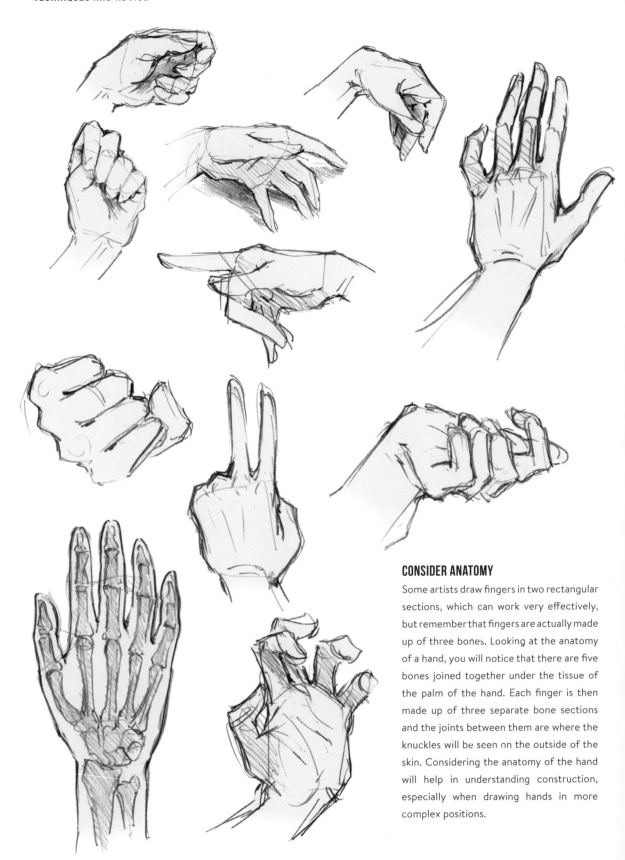

CONSIDER ANATOMY

Some artists draw fingers in two rectangular sections, which can work very effectively, but remember that fingers are actually made up of three bones. Looking at the anatomy of a hand, you will notice that there are five bones joined together under the tissue of the palm of the hand. Each finger is then made up of three separate bone sections and the joints between them are where the knuckles will be seen on the outside of the skin. Considering the anatomy of the hand will help in understanding construction, especially when drawing hands in more complex positions.

DISTINGUISHING THE BACK FROM THE PALM

There are a few distinguishing differences between the back and the palm of the hand. One of the main features of the back of the hand is the skin between the fingers, which cannot be seen from the palm of the hand. Another key difference is that the back of the hand clearly displays the underlying bone structure, such as the knuckles, whereas the palm of the hand is just soft tissue and shows distinctive wrinkles in the skin. From the outline drawing you can simply add a few extra lines to indicate the back or the palm of the hand.

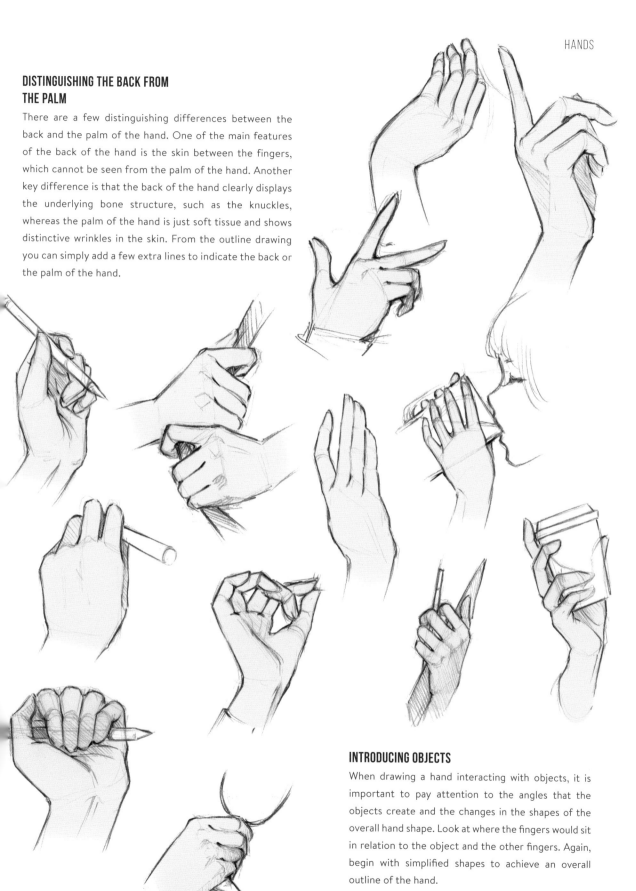

INTRODUCING OBJECTS

When drawing a hand interacting with objects, it is important to pay attention to the angles that the objects create and the changes in the shapes of the overall hand shape. Look at where the fingers would sit in relation to the object and the other fingers. Again, begin with simplified shapes to achieve an overall outline of the hand.

DRAWING HAIR

Here I will demonstrate how I draw different hairstyles in my manga-inspired style. I love to play around with a character's hair; the hairstyle can completely change the look of the character even if their face and head shape remain the same.

Take a look at some different examples here, and have a go at drawing your own. You can be as adventurous as you like with the hair. It can be short, curly, or long and free-flowing, or have bows or butterflies, for example. It is fun to experiment!

SKETCHES AND TEMPLATES

I start by drawing a head without hair, including the neck and shoulders. I like to draw the head at an angle, rather than face on. I then trace this head design several times so I can try out different hairstyles. Feel free to trace one of my head designs to practice on, or you can download and print templates from 3dtotalpublishing.com/resources.

Before you begin to draw each hairstyle I recommend only approaching the paper when you have an idea of what you would like to create, otherwise it can feel overwhelming. This applies to the beginning of any drawing (unless you are warming up of course). Make initial sketches to practice the hairstyle before committing to the final sketch.

The simplest hairstyle to begin with is a bob, so I am going to demonstrate this first. Then I'll show examples of other hairstyles: long, short, curly, wavy, and straight. Of course, these are not the only styles out there; there are still a lot left for you to discover and experiment with. Spend time observing people you see around you, and use social media and magazines, for example, for inspiration and reference.

For the purposes of this demonstration I haven't drawn eyebrows where the hair covers them, although sometimes in manga drawings the eyebrows are visible over the hair.

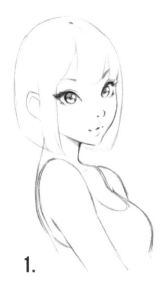

1.

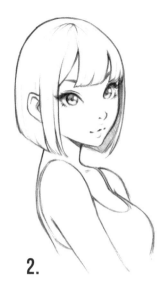

2.

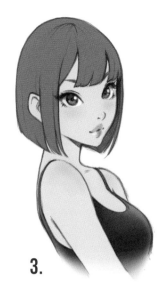

3.

STRAIGHT BOB

1. To begin, I find the middle of the head and mark it with a dot. This will define where the hair falls from. Remember that a head is rounded so any hair you draw will fall outward from the middle of the head or parting and over the head. This is why the lines are neither arcs nor straight. I draw a simplified outline of the shape of the hair first and then add strands. The outline shape is the most important part as it determines the length of the hair. You can alter the thickness and volume by raising the outline of the hair above the original outline of the head shape, if you wish.

2. I thicken some of the lines to add more detail and make the style more interesting. I usually thicken lines where there is a rounded area or corner, where one line meets another, or at the end of a line. Here, I have kept the ear as part of the design because the hair is quite thin and sleek, so the ear would probably peek through.

3. Once I have the overall shape of the hairstyle, I try not to overwork the design by adding in too many extra lines. To stop myself from adding more details or shading, I scan the sketch and add flat colors in Photoshop.

4. I then get carried away with adding details digitally! Drawing is just too much fun! This example is one way you can finish the sketch and you can learn how I color traditional sketches digitally on pages 126–133. This colored illustration is achieved with a simpler process using only two additional layers – a Multiply layer for shadows and a Normal layer for all the light effects.

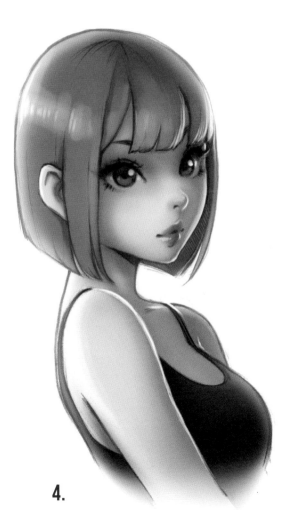

4.

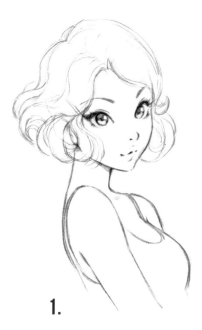

1.

2.

CURLY BOB

Curly hair is a little more challenging, so I have practiced drawing curly hair a lot to make sure I get it right.

1. Since my hair is straight, to get a better understanding of curly hair I look for some references online. I focus on short, curly, fifties hairstyles and observe a very neat and tidy top of the head with slightly wavy strands. The curls only appear at the bottom, giving the hair more volume there. This is what I lightly sketch, with a few simple S-shaped lines that at the bottom transform into big spirals. For this step I use a 0.5 mm HB mechanical pencil.

2. I select some of the sketchy lines to thicken and make separate strands stand out more. Softer pencils are best for this (I use a 0.5 mm 2B mechanical pencil here). I draw over the whole outline of the hair shape to make sure I don't just look at single locks, but instead take in the whole shape of the hair.

3. Adding flat digital colors brings the character to life. Looking at these swirly lines makes me want to have curly hair myself!

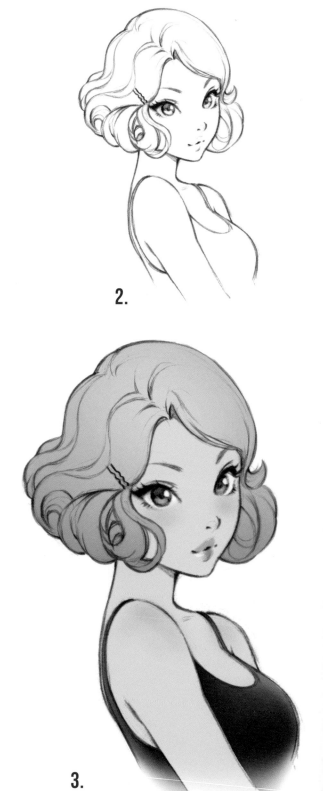

3.

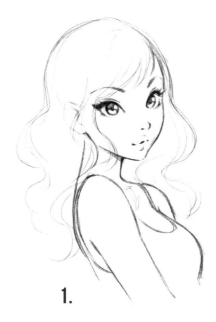

1.

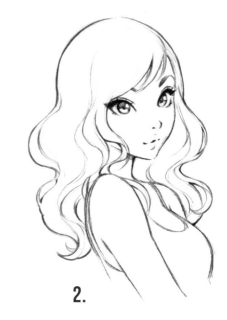

2.

WAVY HAIR

1. To begin this hairstyle, I create a line slightly outside the shape of the head in the template. I always associate wavy hair with fluffiness and volume, and there is a lot of hair to deal with in this style. I draw hair flowing over the shoulders and cheeks too, covering the ear and neck. With a few "swooshy" lines, the base is done. Remember to lightly sketch with a harder pencil (I use a 0.5 mm HB).

2. This step is very important and easy to overdo. I make sure not to separate too many strands within the hair shape but rather keep them as one fluffy shape. To give a bit of breathing space, I pull out thin, single wavy hairs outside on both sides of the hair.

3. The hair surrounds the face and wraps around the shoulders giving it a warm feeling. It makes me think of this character as a snow queen! This is why when I color her in I choose a very bright frost blue, blending it in with its deep dark value.

I will now outline a few more examples of hairstyles so you can see a further range of styles.

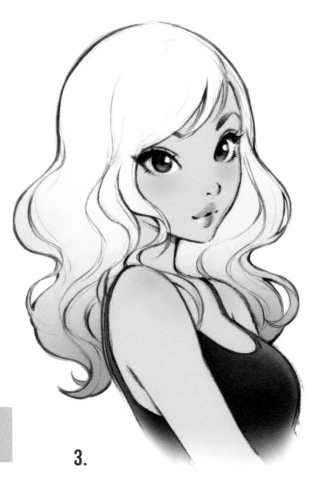

3.

STRAIGHT LONG HAIR

In contrast with the previous long and wavy hairstyle, here is a long and straight one. First of all, the hair lies flat, really close to the head's outline; there is no need for extra volume. The line shapes are important; while the hair is straight, not one of the single lines are straight. They follow the shape of the head at an arc, and when falling on the shoulder the strands also make a smooth arc. The challenge with this hairstyle may be trying to make it look interesting as it is a very simple one, so I add some hair slides and pull out two separate strands at the front.

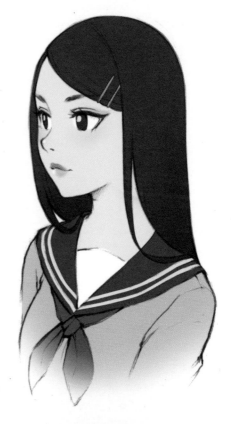

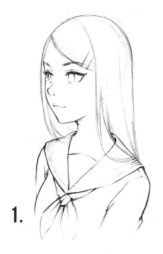

1.

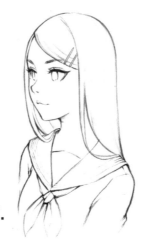

2.

3.

PONY TAIL WITH A STRAIGHT FRINGE

This type of fringe is called *hime cut* (princess cut in Japanese) and is characterized by two longer sides cut at an angle. These drawings demonstrate how straight hair behaves when it is pulled into a pony tail. I exclusively draw straight lines (apart from the arcs where the hair is falling over the head), and leave no naughty strands anywhere. To finish off the hairstyle I add a ribbon and a headband.

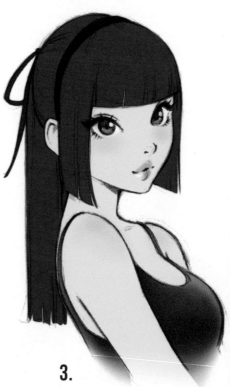

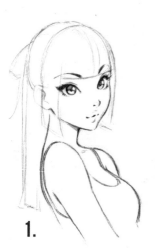

1.

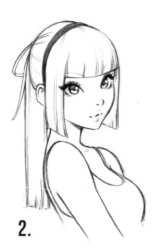

2.

3.

TWIN TAILS – SHOWING THE HAIRLINE

Here, I would mainly like to show you how I draw a hairstyle with an exposed hairline. The overall shape of the hairline is very flexible, as people have different types of hairlines. I begin by drawing a faint hairline sketch, deciding where the hair will be tied back.

I add lines to the hair to indicate strands and follow the direction of the hair when it is tied up (from the hairline at the front to the tie). I have added loose strands of hair to frame the face and make the hairstyle feel more interesting.

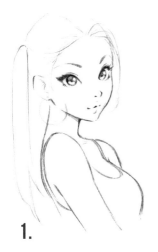

1.

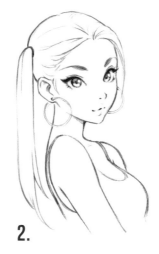

2.

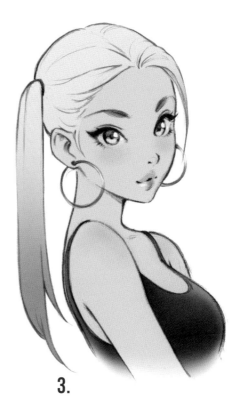

3.

TWO BUNS

Buns are a very popular hairstyle. They can make a character look elegant, playful, or serious – depending on how you draw them. The fluffy buns here are placed really high, making my character look friendly and playful. I make their shapes a little irregular, including some hair sticking out. It is worth noting the direction of the lines and the separation of the main shapes with a thick outline, and in contrast, the delicate and thin details, which are drawn with a harder pencil.

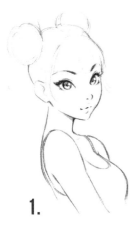

1.

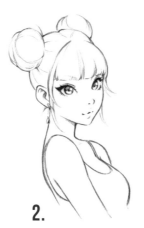

2.

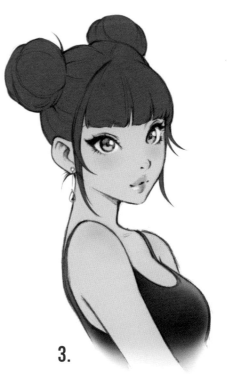

3.

ELEGANT

I merge the two buns from the previous example into one large bun and add a flower decoration. This immediately turns the character into a more elegant one. By also making the hair a little darker, and creating a glowing effect on the flower, it helps to bring the evening-party atmosphere into the illustration.

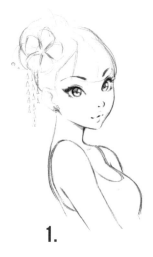

1.

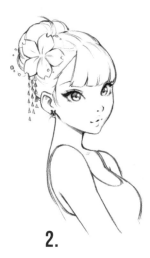

2.

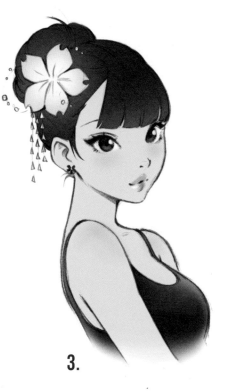

3.

PUNK HAIR

To contrast with the elegant hairstyle I thought of something completely opposite. I think that vibrant spiky hair and a few accessories like a pointy earring, a choker, and a few tattoos work really well to make the same character look more "edgy."

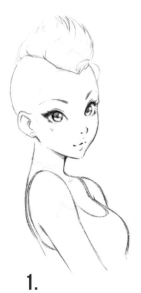

1.

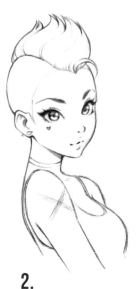

2.

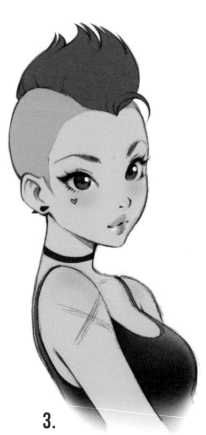

3.

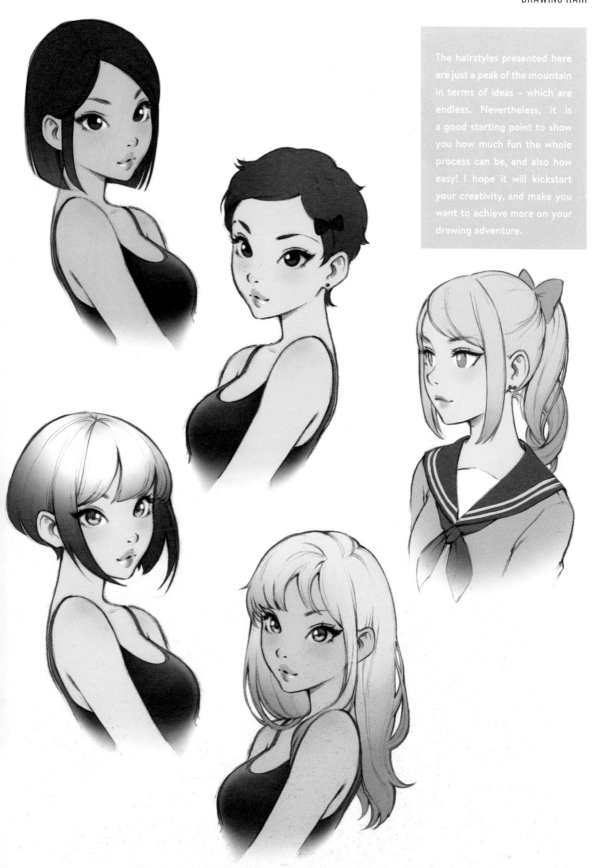

The hairstyles presented here are just a peak of the mountain in terms of ideas – which are endless. Nevertheless, it is a good starting point to show you how much fun the whole process can be, and also how easy! I hope it will kickstart your creativity, and make you want to achieve more on your drawing adventure.

PROCESSES

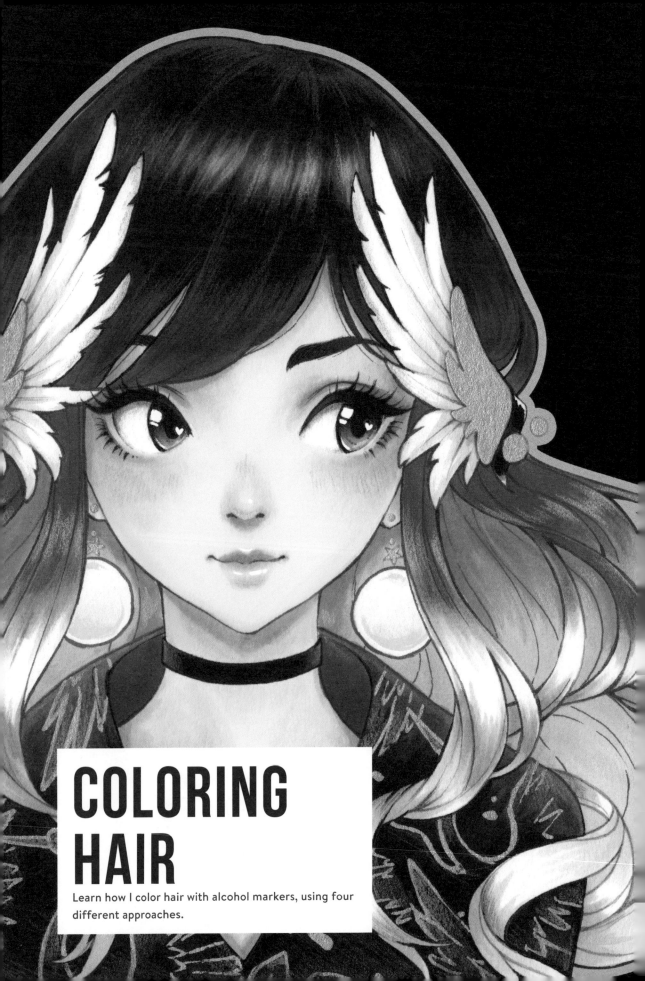

COLORING
HAIR

Learn how I color hair with alcohol markers, using four different approaches.

To get started, lightly print out a few of the same head designs onto thick watercolor paper; you can download different templates I have created from 3dtotalpublishing.com/resources, or just use your own. This will mean you can focus on practicing coloring without worrying too much about how to draw the shape of the hair.

Note that it is important to use good-quality paper in order to ensure that the markers do not bleed too much. If you are creating your own line art template, remember to lower the opacity to 30% before printing, to ensure your coloring can hide the printed lines.

To decide which color combinations you want to use on the hair, first develop a test sheet, making a note of which colors you use for each. Refer to a color wheel or chart of your available markers to decide which colors might complement each other – for example, shades from the same family often work well together.

Create your color reference sheet on the same type of paper that you will be working on so you can understand how the pens will behave. Colors blend differently depending on the paper you use, which can even result in varying tones of color from the same pen.

In this process overview I will refer to the Copic numbering system so you can observe how I have made certain marker choices. Each Copic color has its own code consisting of a letter or letters at the start followed by two numbers. The letters indicate the color family of the ink, for example R refers to red and BG refers to blue-green. The first number in the sequence indicates the ink's saturation – the lower the number, the more saturated that color will be. The second number reflects the brightness of the color – the lower the number, the lighter the color will be.

I have included the Copic marker numbering in this chapter as supplementary information for those using these markers; even if you are not using Copics, the numbering will still give you an idea of how to select marker colors when blending hair. (If you are using a different brand, make sure you understand their number codes.)

TEMPLATE HAIRSTYLES

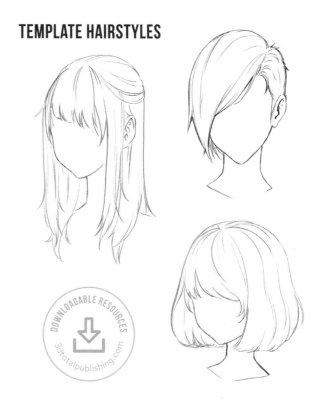

TEST SHEETS

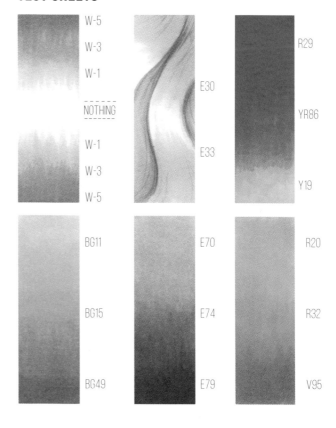

APPROACH 1: LIGHT TO DARK

For this first hairstyle, I have chosen Copic markers from the same color family for a more cohesive color blend. The color test sheet I created on the previous page helps to guide the color choice.

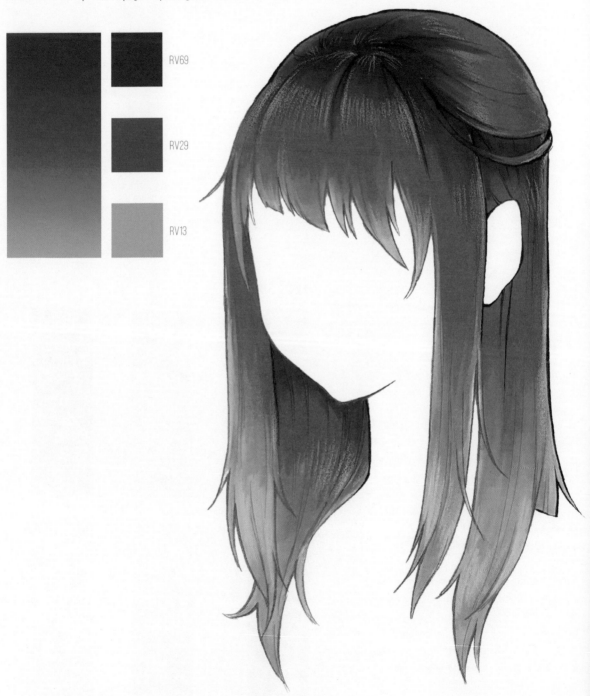

RV69

RV29

RV13

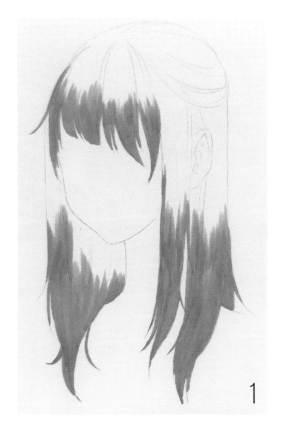

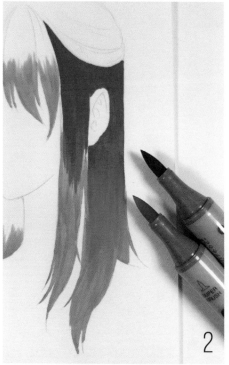

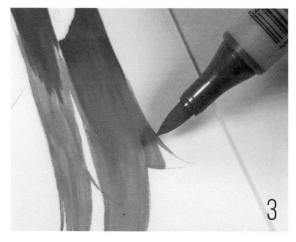

TIP: Even though you need to work relatively quickly, try to be patient as you build up the layers. Note that the more layers you have, the darker the tone will become. It is important to keep this in mind so you don't oversaturate your image, but it is also a useful feature of the markers to be able to achieve a wide range of values with just one ink.

1. Using one of the printout hair templates (see page 113), I start by adding the lightest color to the bottom of the hair. I begin at the bottom and brush upwards as if using a paintbrush rather than a pen. I decrease the pressure of the tip as I work upwards to achieve a gradient of saturated to less saturated color.

2. Next, I start adding the mid-tone marker in the middle of the hair. The trick here is to not simply use the mid-tone marker but to also use the lighter one at the same time to blend and smooth the transition. I continue working with both pens to add volume to the middle sections of the hair and fringe. It is good to work quickly if you can as when the ink dries it is harder to blend.

3. Instead of endlessly layering RV13 and darkening the color of the ends to achieve smooth blending, I use a lighter shade of pink as a blender. In this case, I ran out of RV10, so I opted for the next lightest one I had, which was RV21.

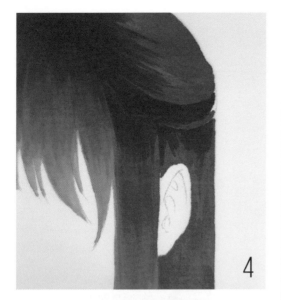

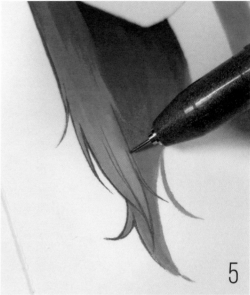

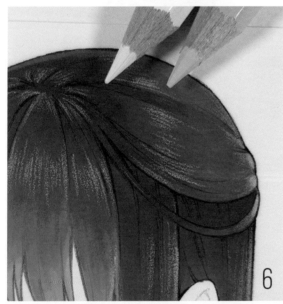

4. I add the darker color coming out from the center of the scalp and underneath the jawline where shadow will be most prominent. I use the mid-tone marker to blend the darker value in as I did with the two lighter markers before.

5. At this stage, the printed line art isn't visible underneath the ink. Once I am happy with the color I add the line art back in using a black and dark pink fineliner to add detail. An easy mistake to make is to use the wrong color fineliner – black is a safe option; otherwise use a darker version of the base color.

6. When finishing the line art and coloring stages, the hair may look a little dull, so I use a white coloring pencil to bring out highlights on top of the ink. I am also using a blue coloring pencil to add a secondary light, creating a more interesting effect. Using references helps me to add the highlights accurately.

TIP: Adding the line art after the coloring stage means that the ink from the fineliner doesn't become smudged by subsequent coloring. Alcohol markers can dissolve ink that is already on the paper and create smudges when using lighter colors. The disadvantage of using this technique is that for most of the process the drawing doesn't look quite right. I have now learned to trust my instincts and skills and not abandon the drawing when it doesn't look correct, so have faith in yourself and keep practicing!

APPROACH 2: DARK TO LIGHT

For this method I try the reverse, working from dark to light shades. Again, I use markers from the same family. Unlike the previous method, I add the line art to the bottom of this image first because the marker is very dark and I want the detail lines to still be visible once color is added. The rest of the line art, where the color will be lighter, can be added at the end so that the lines are not smudged; smudges of line art on a dark color are less of an issue because they are not as obvious.

V01

V06

V99

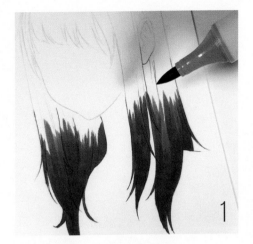

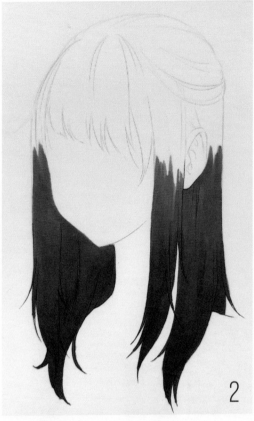

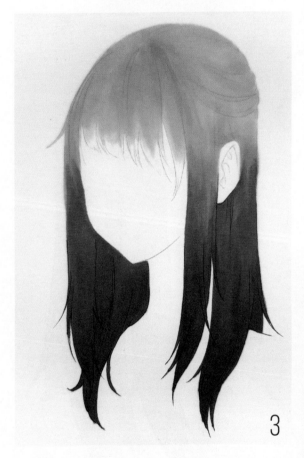

1. This begins the same way as the light-to-dark approach (see page 115), brushing the ink to achieve a gradient, this time working from dark to light. I leave only one layer of ink where I know that the color will be blended into the next marker. By layering up the darker marker at the bottom of the hair you can achieve multiple values through just one ink.

2. I now start adding in the next marker, coloring over the darker marker as well to help unify the tones. Again, I keep layers to a minimum where I will be blending with the lighter color in the next step.

3. Once the mid-color is added, the same technique is used to add the lightest color. To create a good flow of lines when coloring hair, I work up and down the strands to ensure movement and realistic coloring.

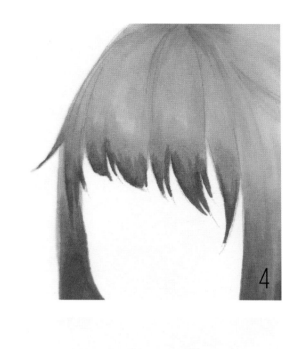

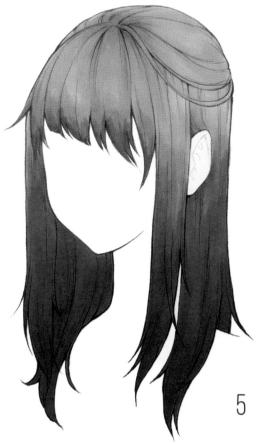

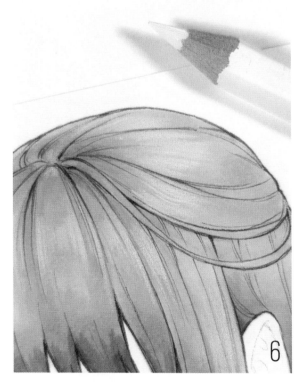

4. For the fringe, I add layers of the mid-tone color to the bottom, fading out toward where they will blend in with the lighter color. Adding extra value around the center of the scalp can help the hair look less flat.

5. Once all the color is in place, the line art can be added for the top of the hair as well. As it is a lighter color, I use a dark purple liner rather than just black. Another advantage of adding the line art at the end is that you can redefine the outline of the hair; sometimes when you are coloring around line art you can go outside of the lines, which can be tricky to fix. Adding the line art at the end makes this easier to avoid. To fix any areas of line art where you have gone over the lines with color ink, you can make the lines thicker. (It is better to use lighter-colored fineliners to add details to paler hair coloring as black may be too harsh for a delicate style and coloring.)

6. For the final touch, I add highlights using white and blue coloring pencils again. Particular areas of highlight include the round parts of the hair – the fringe at the front of the head and the crown. I add highlights to the curves where the hair falls on the shoulders, too.

TIP: Both the light-to-dark and dark-to-light approaches work well – the key is to ensure smooth blending of the values.

APPROACH 3: ADDING VALUE WITH ONE HUE

This method is a bit different to the first two approaches: here the dark hair appears to be one shade all over. In the previous approaches I used colors from the same color family; for this technique I also use colors with the same saturation level. Using pens with these attributes creates a unified look as they have been designed to complement each other.

E70

E74

E79

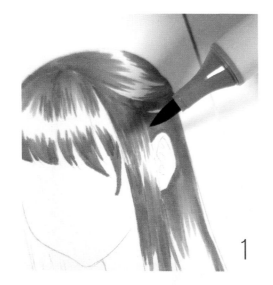

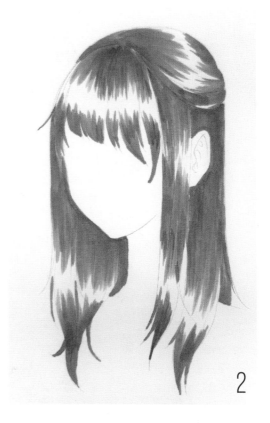

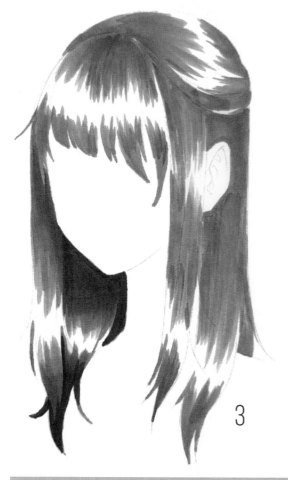

1. As this finish is darker, it doesn't matter when you add the line art, but it may be neater to add it at the end of the coloring process. For this method, I start with the mid-tone color (E74) to establish the key areas of color for the hair, leaving white spaces where light would naturally land. This gives a stronger highlight to the overall finish.

2. I continue to add the mid-tone color to the hair. As this hair color is intended to appear as just one shade of brown, there is less blending involved in this method. This means special attention needs to be paid to the brushstrokes to ensure there is smooth texture and transitions. I build up the tonal finish gradually, creating darker areas from more layers around the tips of the hair, around the center of the scalp, and in areas of shadow.

3. Now that the main volume of the hair is defined I use the darker marker to add in areas of more intense shadow. Observing real-life objects and people can help you understand the effects of light and how to display it in your coloring. For example, here the hair by the neck will be darker as it would have no direct light shining on it.

TIP: Be mindful that some papers may not react well to multiple layers of ink so you may need to approach the layering with caution.

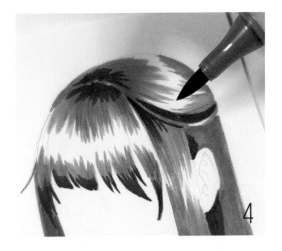

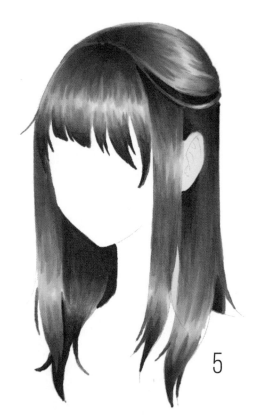

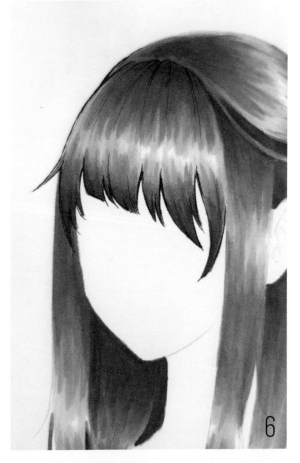

4. I continue building up shadow with the darker ink. I make sure I am consistent with where I place the shadow, creating something realistic rather than something that looks incorrect to the eye. This requires a lot of practice and real-life observation. The first layer of darker ink is really harsh, but I revert to the brighter color to smooth out the blending.

5. At this stage I use the lighter marker to blend the mid-tones in with the highlights in order to create a softer, more unified look. To ensure the highlights remain distinct, I make sure to leave some areas white. The contrast between light and dark gives the hair volume and interest.

6. I finish by using a fineliner to redefine the hair details. If needed, further highlights can be added with blue and white coloring pencils. I use a blue pencil to add a backlight again, creating consistency with the other images.

TIP: Don't forget that the paper is not stuck to your desk! Rotate the page as needed so you can comfortably move your wrist and hand in a smooth arc to achieve smooth strokes. Even drawing upside down for a bit can be easier.

APPROACH 4: FLAT COLOR

For this approach I tend to use a cheaper paper like regular printer paper as flat color works well on it. Flat colors spread better on this than watercolor paper, but they can bleed through, so work quickly and try not to use too much ink. The method is inspired by the art of Eisaku Kubonouchi (twitter.com/EISAKUSAKU), an incredible Japanese manga artist who I am a big fan of. It looks flatter than the effects produced by the previous techniques but has a more graphic and bold finish. I use markers from the same family and same saturation value again as I did in the third approach (see page 120).

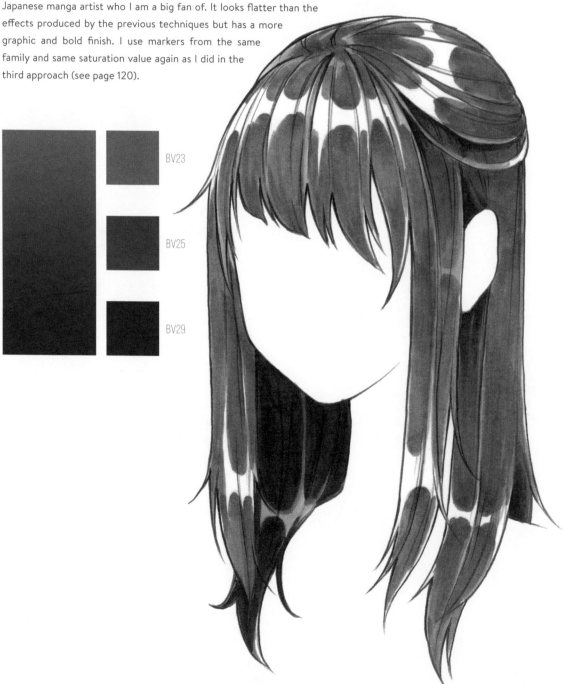

BV23

BV25

BV29

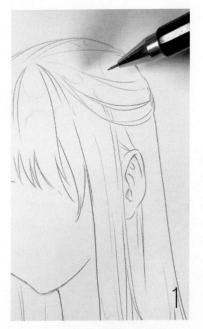

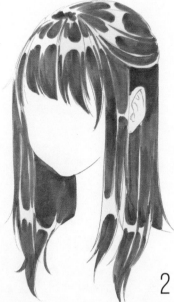

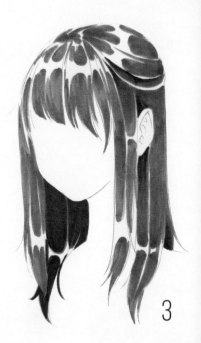

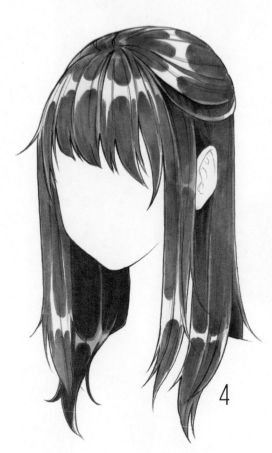

1. Starting with the mid-tone marker, I color the hair strands using broad strokes to create movement and fill in the initial design. This technique has slightly more complexity to it in that the white paper highlights play a more significant role and it can be tricky to see where these should be placed initially. It can be useful to draw these highlights lightly with a pencil before starting inking.

2. I continue working quickly using broad strokes to fill in the hair. I am careful to leave the highlight areas white as these will not be blended in the same way as in the previous method and will help to give the hair that more graphical look.

3. Using a darker marker adds areas of more intense shadow, increasing the contrast between light and dark. The lighter marker can also be used at this stage to soften some of the transitions from light to dark, while still maintaining those areas of bright white. I make sure to work up and down the strands of hair in a smooth way, thereby avoiding messy brush marks.

4. As this coloring method uses less ink and blending, the final colors can look a bit flat; this is where the detailed line art touches bring the hair to life. To finish and redefine the hairstyle, I simply use a pencil.

Experiment with these techniques and find what suits you to develop your own style, but remember to be brave with your coloring, and most importantly, have fun and enjoy the creative process!

EXAMPLES

Have fun experimenting with different palettes using these four techniques. Here are some more examples.

R29
YR68
Y19

APPROACH 1: LIGHT TO DARK

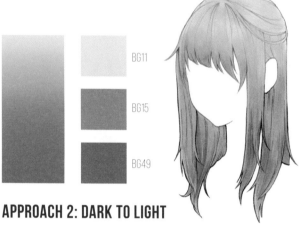

BG11
BG15
BG49

APPROACH 2: DARK TO LIGHT

R20
R32
V95

APPROACH 3: ADDING VALUE WITH ONE HUE

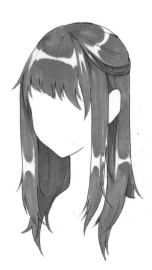

PAPER·
YR68
R08

APPROACH 4: FLAT COLOR

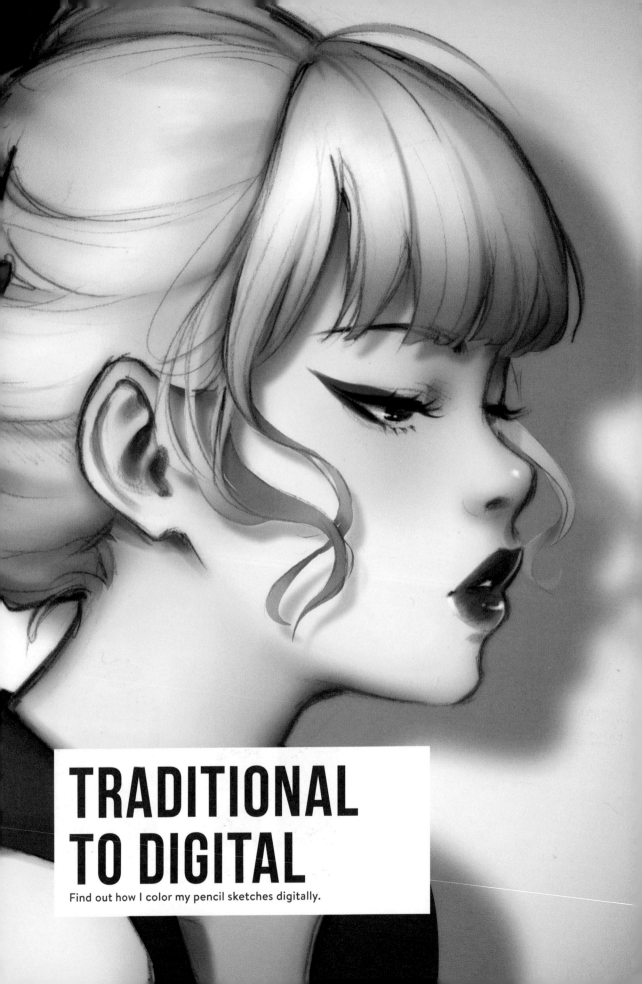

TRADITIONAL TO DIGITAL

Find out how I color my pencil sketches digitally.

My go-to technique when sketching is always pencil on paper. I have used this method the longest and feel the most comfortable with it, but for a long time I didn't know how to bring my pencil sketches to a more finished-looking result. This is when I saw that other artists online color their pencil sketches digitally. I thought this was a great idea and developed my own method to make the most of it.

I will be using Photoshop to paint digitally. While I won't go into too much detail about the tools, I hope to give you an insight into the process I use; if you would like to learn more about digital painting there are plenty of great online resources and books available.

1. SKETCHING WITH PENCIL

Here I've sketched out a character in my Moleskine A5 sketchbook, using mainly 2B 0.5 mm and B 0.7 mm mechanical pencils. This is a sketchbook I always have with me, no matter where I go and whether I plan to draw or not. This sketch was made in one of the moments I didn't plan to draw, but I took my sketchbook out and just started doodling!

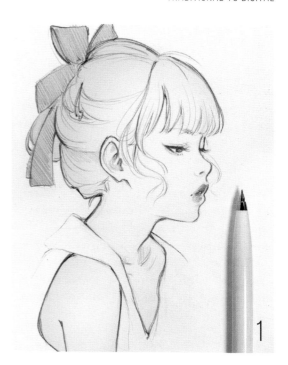

1

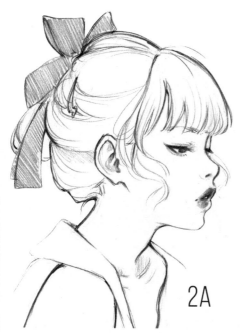

2A

2B

2C

2. SCANNING THE IMAGE

For digital coloring, I sometimes use the photo of the drawing that I take for Instagram. However, it is best to scan the sketch properly, so it is better quality and requires less editing! I scan at 600 dpi (2A) and adjust the Photoshop Levels to make the pencil stand out more (2B). The Brightness/Contrast adjustment filter does the job too! Lastly, I make the sketch black and white (2C).

3. GROUPING COLORS

For those who have not worked digitally before, many artists use layers in Photoshop, which allow you to work on different elements individually, a bit like working on single sheets of tracing paper stacked on top of each other.

On separate layers then, I make flat blocks of colors for all the separate parts of the illustration: the background, hair, ribbon, skin, and shirt. More complex drawings have more layers, of course! The colors don't really matter at this stage – they can be easily changed. I also can't stop myself from adding small touches like blushing cheeks, makeup, and a second color on the hair layer, but these can be added later.

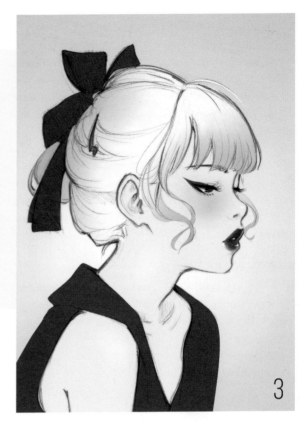

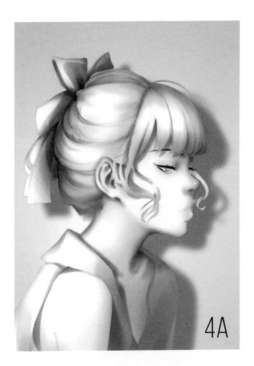

4. CREATING SHADOWS

I switch off the visibility of all the colored layers and group them in a folder. Then I create another folder and, on separate layers again, make the shadows for the particular color layers (4A shows the layers where I worked on the shadows). The end result should look as shown here (4B). What is important in this step is establishing the light source; I decide on a soft light coming from the front left side.

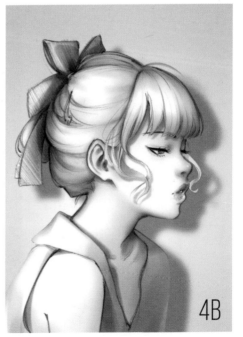

5. APPLYING SHADOWS

The simplest method to apply shadow layers to the drawing would be setting all the layers to the Multiply blending mode, but it doesn't work well in this case. The illustration turns gray and it seems like something has gone wrong in the process. This is why I keep the shading on separate layers too (5A). It may seem a bit complicated and unnecessary (and maybe it is!) but I find that adding Clipping Mask layers with color to particular shadow layers is a perfect solution for me. I pick colors that are darker and more saturated than the flat color of the illustration (5B). What I love most about this method is that the colors are easy to change at any time!

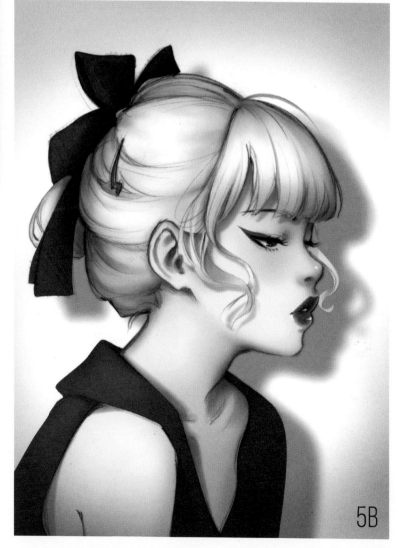

PHOTOSHOP TIP:
TO QUICKLY SELECT A FILLED-IN AREA ON A SEPARATE LAYER (LIKE MY LAYERS WITH FLAT COLORS), JUST CLICK THE LAYER THUMBNAIL WHILE HOLDING THE CTRL/CMD BUTTON.

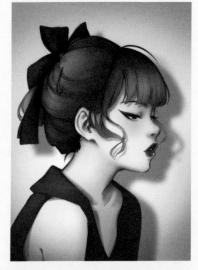
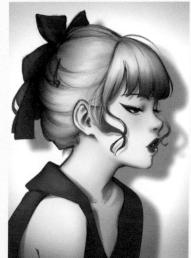

6. CHOOSING COLORS

It may seem unusual, but I don't pay too much attention to my choice of colors until this point in the process. This is when the fun of experimenting begins! I sometimes get lost in all the possible color combinations, but it is so much fun to see how different palettes bring different moods and feels to the whole illustration. My only problem is choosing a favorite!

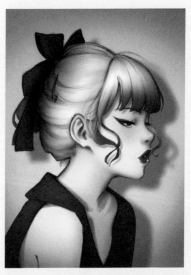
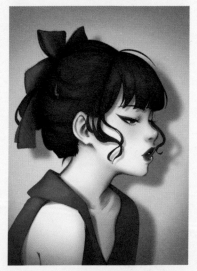
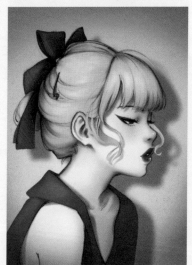

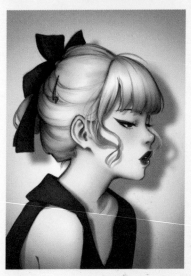
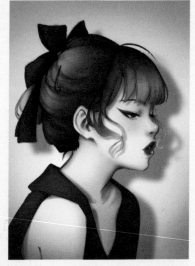
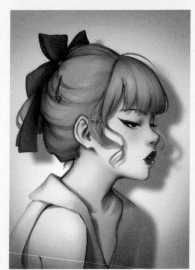

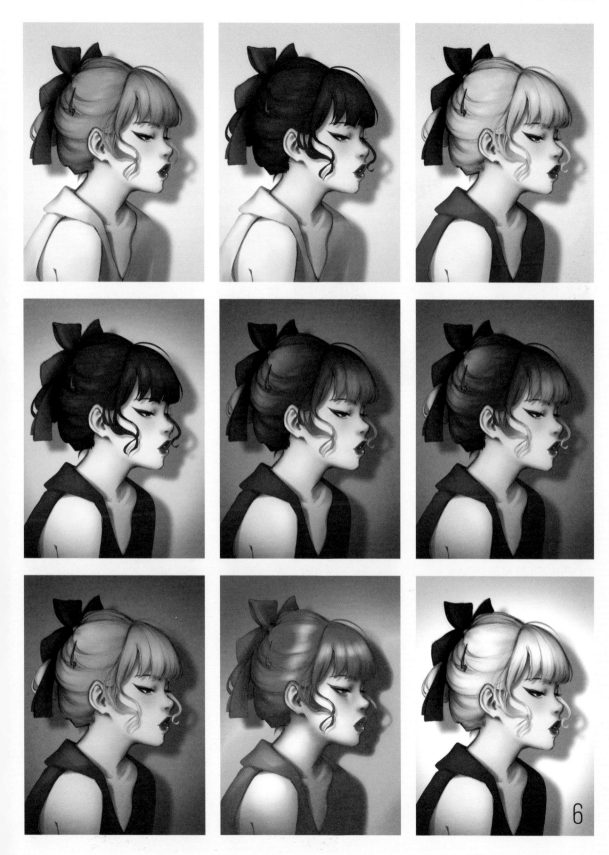

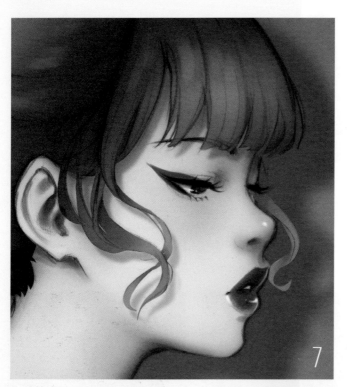

7. ADDING DETAILS

When I manage to choose a favorite, I sometimes add a layer on top of all the others and paint some details like highlights on the hair, nose, or eyes, covering some of the pencil lines. There is a lot that can just be painted; in fact, I could have painted the whole illustration on one layer from start to finish, but that isn't the point of this demonstration! This process is good for those that don't have the confidence to just paint the whole idea from start to finish. It involves experimentation and doesn't look overly polished like some digital illustrations do. This is still very much a traditional drawing, just with a digital splash of color!

8. EXPERIMENTAL NEON VERSION

Here is an example of a more experimental version, involving a lot more painting than just changing the colors of flat layers and shadows. Using the layers from before, I am able to select areas quickly and fill them in with a main color, but the majority of colors, lights, and shadows have to be chosen and painted manually.

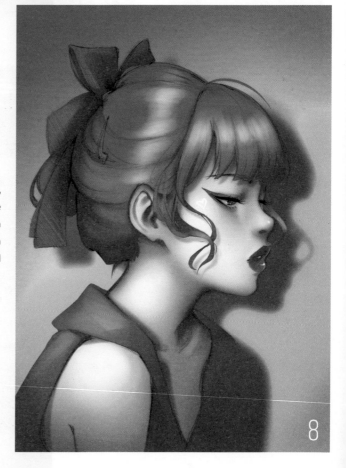

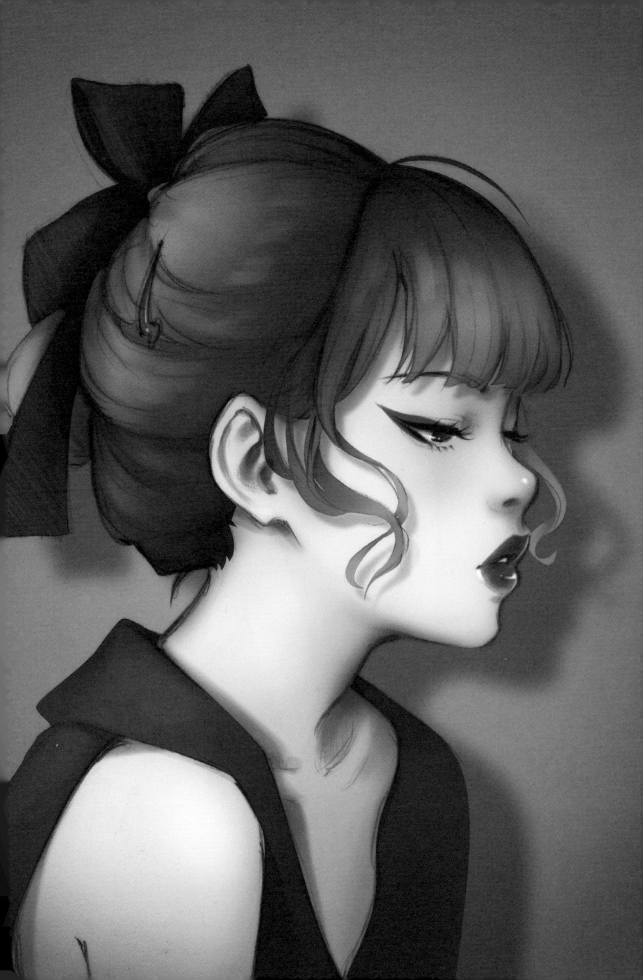

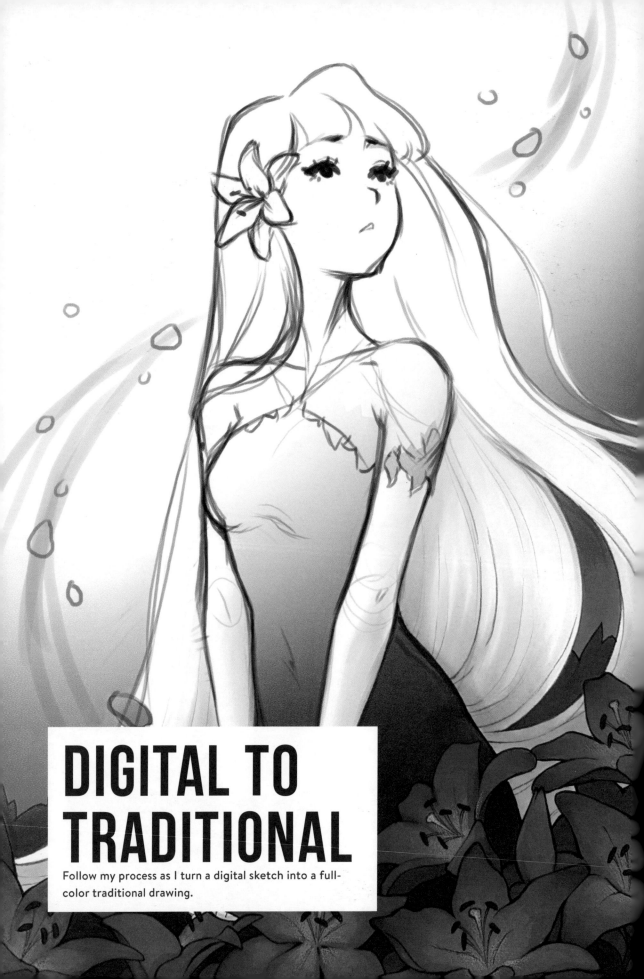

DIGITAL TO TRADITIONAL

Follow my process as I turn a digital sketch into a full-color traditional drawing.

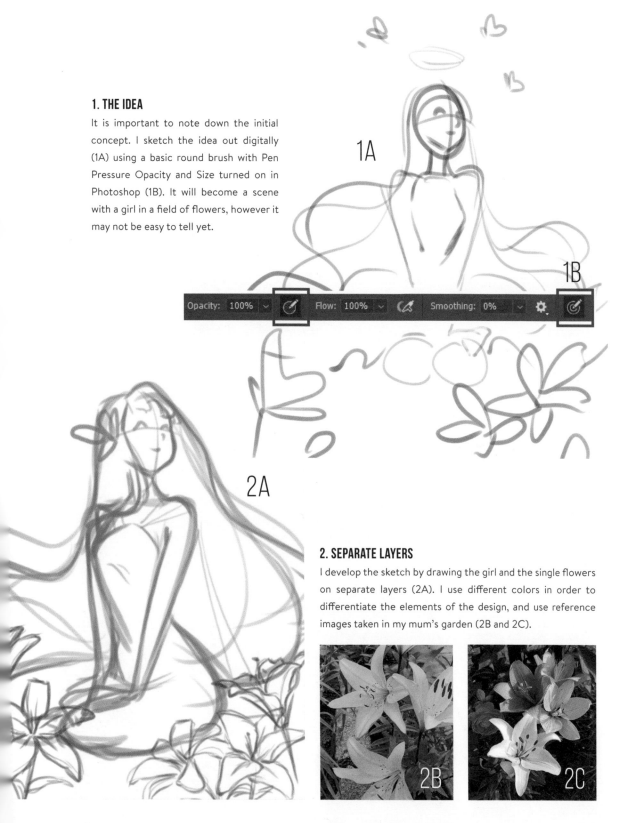

1. THE IDEA

It is important to note down the initial concept. I sketch the idea out digitally (1A) using a basic round brush with Pen Pressure Opacity and Size turned on in Photoshop (1B). It will become a scene with a girl in a field of flowers, however it may not be easy to tell yet.

1A

1B

Opacity: 100% Flow: 100% Smoothing: 0%

2A

2. SEPARATE LAYERS

I develop the sketch by drawing the girl and the single flowers on separate layers (2A). I use different colors in order to differentiate the elements of the design, and use reference images taken in my mum's garden (2B and 2C).

2B

2C

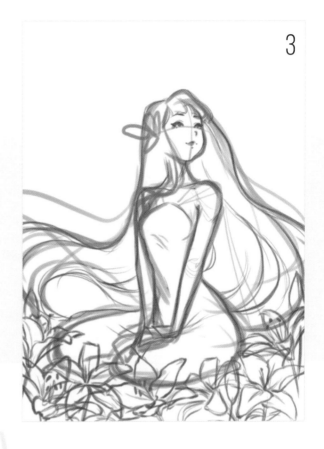

3

3. THINNER LINES

On a new layer, I use a much smaller brush to add definition to the girl. Once I am happy with how I have drawn the details, I delete the messier sketch. Looking at how I positioned the flowers here, there is something about the composition that is bothering me, so I will tackle this in the next step.

4. COMPOSITION

The composition of the design appears too heavy in the bottom corners, and although the hair has movement, I feel like the illustration still looks static. I rearrange the flowers and hair (4A and 4B) to make the girl look like she is sitting on a hill, looking toward higher ground or to the sky. To balance the shift of many elements to the right side of the design, I add a breeze of petals flying around her in a spiral.

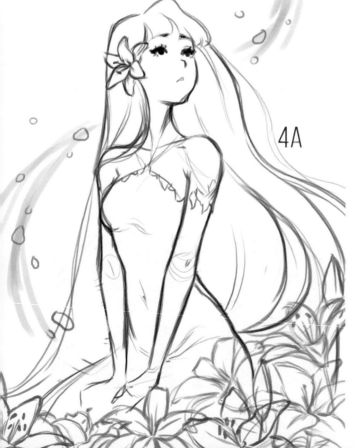

4A

4B

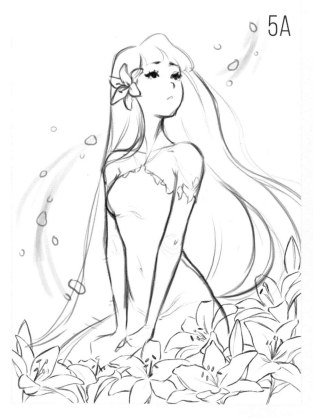

5A

5. READY TO DRAW

Next, I apply grayscale to my digital sketch (5A) and print it out in the format I want the drawing to be on paper. Using an LED light box, I transfer the digital sketch onto the final paper (5B).

5B

6A

6. SKETCHING ON PAPER

The sketch I printed was still messy, so I refine the design further on paper. I use Canson Moulin du Roy hot-pressed watercolor paper for most of my Copic drawings, and to trace the outline I use a mechanical pencil with Nano Dia pink lead inside (6A and 6B). Pencils have a tendency to smudge and make paper dirty, so using a pink erasable color, which is much lighter, helps keep the paper clean (6C).

6B

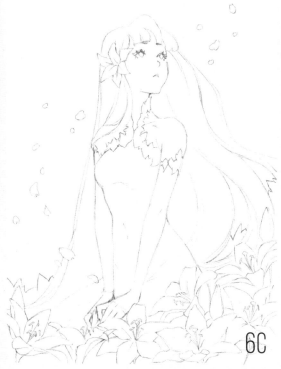

6C

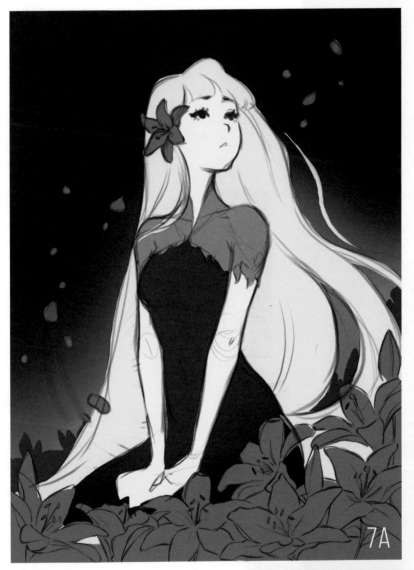

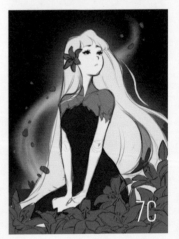

7. BEFORE INKING

For ease and speed, I return to my digital sketch to try out a few different color schemes (7A–7E). I prefer to use colored pens and not just black ink for the line art, and the colors need to match the colors of the markers that I will use later, so I need to decide on the color palette first!

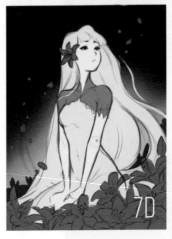

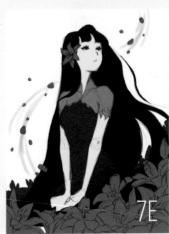

8. TRANSLATING DIGITAL TO TRADITIONAL

In order to decide which colors I want to use in my final piece, I print small versions of the digital sketch and test out marker colors according to the combinations I had explored digitally. Through doing this, I discover that some of these digital colors are really hard to achieve with markers and that I'll have to improvise!

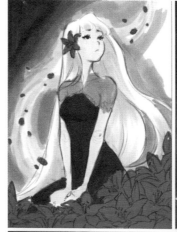
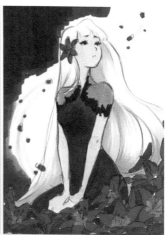
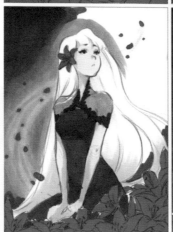
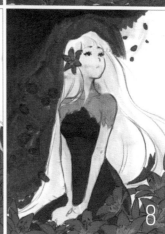

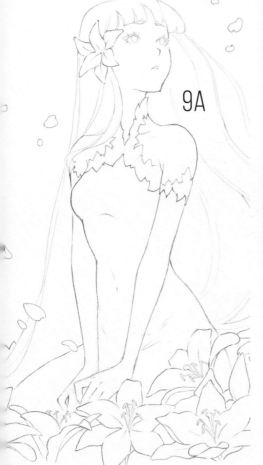

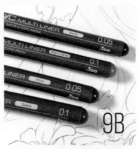

9. INKING THE LINE ART

After choosing a color palette I select pens for my line art that will match the markers to be used to color the whole design (9A and 9B). My rule is to use a darker ink to the marker color, for example, for the peachy skin I use a sepia Multiliner and for the dark red dress, I use black. I also used a wine Multiliner for some details but had to change it at a later stage to black as it turned out to be too light for the marker colors I used (9C).

10. LIGHT COLORS FIRST

I always start by coloring with the lightest markers in my chosen scheme. There are two reasons for this: firstly, light tones can pick up dark ink that is already on paper and create unwanted smudges; and secondly, it is possible to darken light color if required, but lightening dark shades is very difficult and sometimes not possible. Therefore, I start by coloring the skin using Copics R0000, R000, R00, and R11.

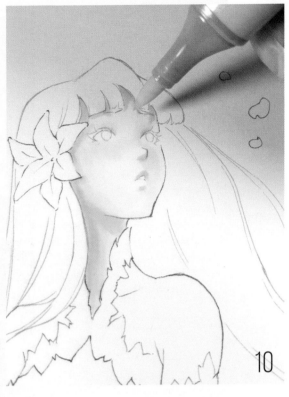

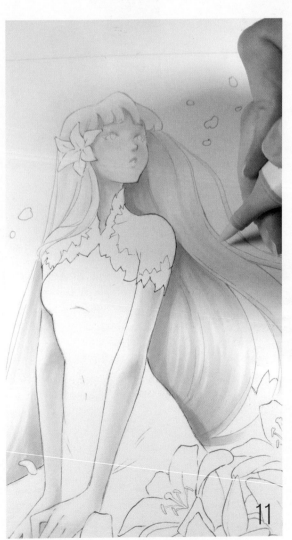

TIP: KEEP THE LINE ART SKETCHY. OVERLOADING INK NOW MAY CAUSE IT TO SMUDGE WHEN USING MARKERS.

11. COLORING HAIR

To color the blonde hair, I use markers in a range of light yellow and peach tones (YR30, E50, E51, R20, R30, and even some cooler B60), building up tone and volume, as demonstrated in the overview of coloring hair on pages 112–125.

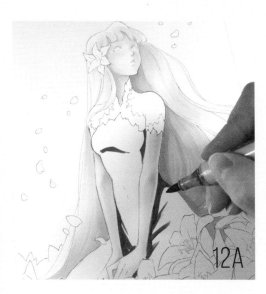

12. COLORING THE DRESS

To build color on the dress, I use a cool gray marker (C7) to add in the darkest parts first (12A), in order to develop strong shadows and create contrast in the final image. Next, I color the dress with a slight gradient by blending red and purple shades (R39 and RV99). I touch the end of the red marker (R39) with the darkest purple marker (RV99) a few times, to darken the ink enough to achieve the desired effect and a smooth transition (12B).

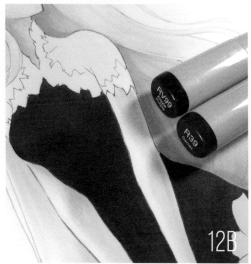

13. COLORING THE LILIES

In order to build up effective coloring on the lilies, I blend bright pink, deep red, and purple shades (RV29, RV25, and R39). These shades work harmoniously together, and different tones give the flowers more volume and finesse. I use a more saturated color on the outside part of the petals (13A) and a lighter color within the flower (13B). The deep red lilies complement the girl's dress and build a glowing warmth and area of interest in the lower part of the scene (13C and 13D).

14. BUILDING THE BACKGROUND

Moving on to the background, it takes many layers of ink to create a smoothly blended gradient. This requires switching markers constantly to ensure that the ink doesn't dry before it has been blended together.

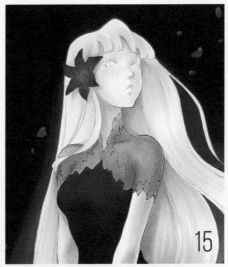

15. CREATING A GLOW EFFECT

I use black for the outer and top parts of the background, keeping a red glow around the lower part of the image and the girl's hair. I color the floating petals using the same colors as I did for the lilies.

16. DEFINING THE DETAILS

Once I am happy with the background, I add line art in order to define the details. For this, I use a Multiliner pen in black. I add details to the flowers, clothing, face, and overall design. I take my time to make sure each mark is correct and adds to the image.

17. FINAL TOUCHES

I finish by adding final touches and highlights to the design using coloring pencils, for example, on the inside of the lilies and on the edge of the girl's dress. This adds extra contrast and interest to the scene. You can see the final artwork on the right.

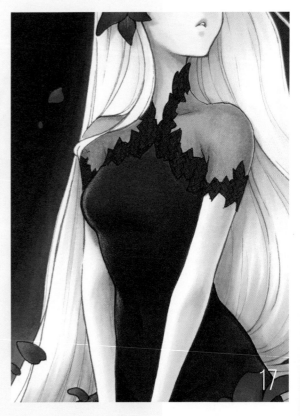

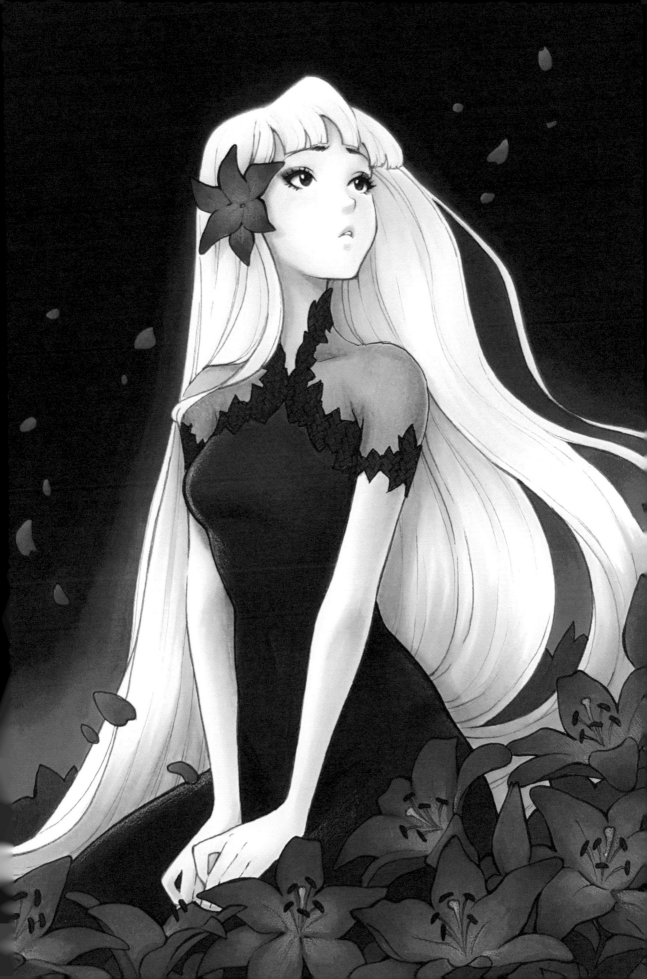

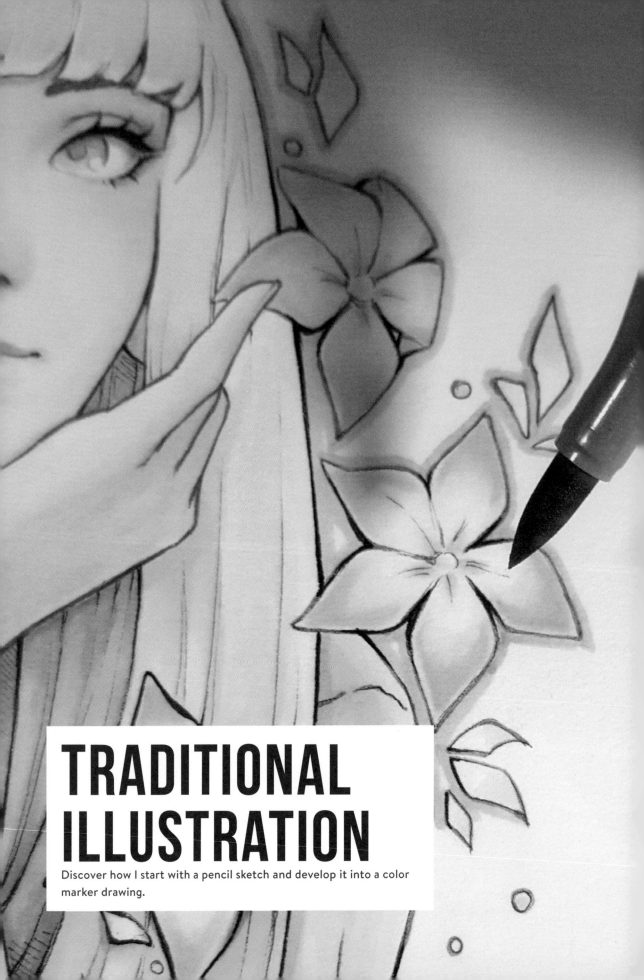

TRADITIONAL ILLUSTRATION

Discover how I start with a pencil sketch and develop it into a color marker drawing.

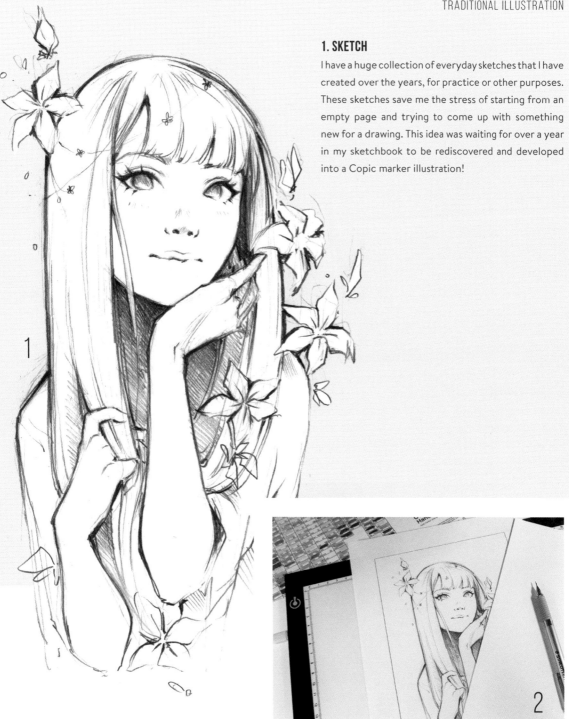

1. SKETCH

I have a huge collection of everyday sketches that I have created over the years, for practice or other purposes. These sketches save me the stress of starting from an empty page and trying to come up with something new for a drawing. This idea was waiting for over a year in my sketchbook to be rediscovered and developed into a Copic marker illustration!

2. FIRST STEPS

I transfer the sketch from my sketchbook to the heavy paper that I usually use for marker illustrations (300 gsm Canson Moulin du Roy hot-pressed watercolor paper). Transferring can be done in many ways. More advanced artists can just redraw it freehand, but here I opt for a simpler method, which is to scan and upscale the sketch digitally, print it out, and trace it using a light box.

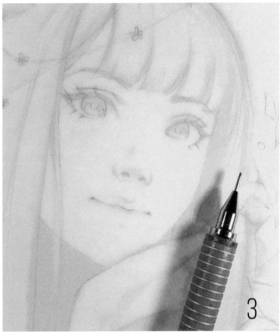

3. COLORED PENCIL

When tracing the outline, I usually use a mechanical pencil with a colored lead (pink, light blue, or red). The results are lighter than normal graphite, and some brands that I use (like Uni Nano Dia) are a lot easier to erase without leaving any trace.

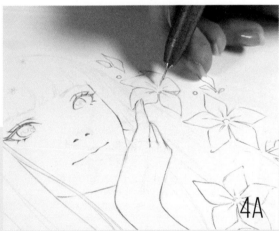

4. INKING THE OUTLINE

I use thin (0.05 mm) colored Copic Multiliners to lightly ink the outlines (4A), and then erase the pencil. Using a sepia pen for outlining skin areas makes skin tones stand out better and look warmer (4B). I make sure not to draw very thick outlines yet, as the pen ink sits on top of the watercolor paper's surface, at risk of being smudged by alcohol markers. I will draw thicker line weights toward the end of the whole drawing process.

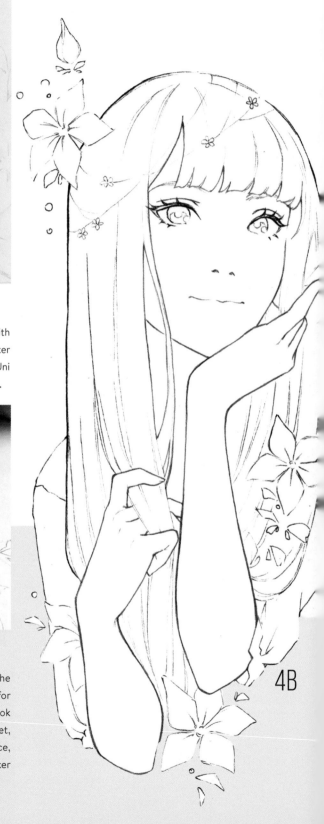

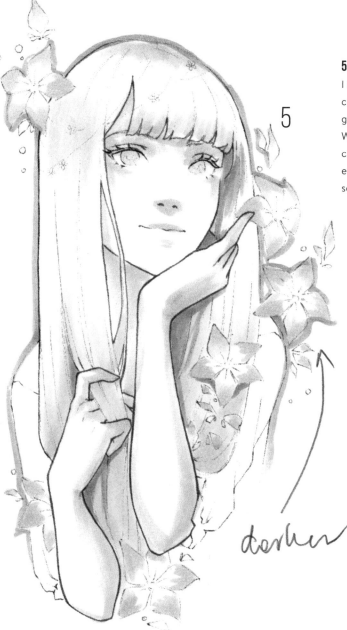

5. COLOR TEST

I scan the line art, print it at a small size on regular copier paper, and run quick color tests to see the general look and feel of the palette I had in mind. Without having an idea beforehand, this process can sometimes take me the longest! But here I know exactly which colors I want to use, and I'm happy to see them work together well on my test thumbnail.

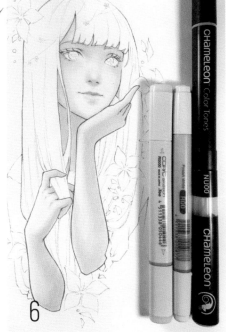

6. COLORING SKIN

I tend to use this color combination in almost all my marker drawings, as I find it very effective. I establish which side the light is coming from, then use a Copic R000 (Cherry White) marker to build up ink slowly. One layer is hardly visible after drying, but layering the same color makes it stronger and creates beautifully smooth transitions. To achieve a darker color, I use Copic R00 (Pinkish White) and blend it using R000. You can also see a Chameleon NU00 (Nude) marker pictured, which I dilute a lot and apply only one thin layer of. There are parts I do not color at all, letting the white of the paper show.

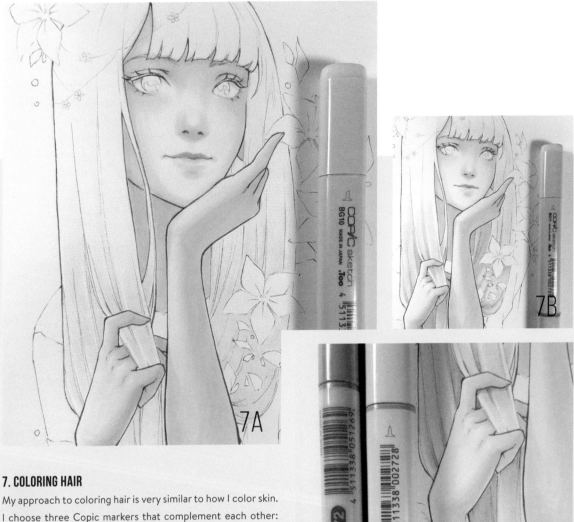

7A

7B

7C

7. COLORING HAIR

My approach to coloring hair is very similar to how I color skin. I choose three Copic markers that complement each other: BG10 (Cool Shadow), BG11 (Moon White), and BG72 (Ice Ocean). I layer them slowly, starting from the lightest color. To create smooth blending, I switch often between the markers, blending BG72 with BG10 while the ink is still wet (7A–7C). Both the skin and hair are still unfinished at this stage, but I'll move on to painting flowers and come back to detailing the character later.

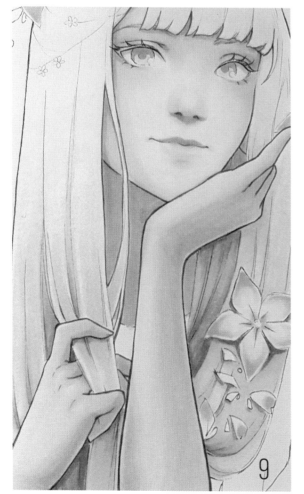

8. FEELING BLUE

I decide to use very delicate, harmonious blues for the flowers: Copic B41 (Powder Blue) blended with B60 (Pale Blue Gray) into the creamy white color of the paper (8B). By now I believe you can see the pattern of me working with caution! I often start from very delicate colors and darken them gradually, rather than going straight in with a dark color to save time. I enjoy seeing the process of the artwork coming together step by step, without rushing to get results.

9. HARMONY

Colors influence one another, both in nature and illustration, and often reflect in each other. I introduce some of the greens and blues I used before into the darkest areas of the skin (and soon I'll also bring a little of the skin tone to the hair) to make all those colors work in even greater harmony. I make the character's eyes blue to create an attractive, flowing line of composition together with the flowers.

10. COMPLEMENTARY PINK

In color theory, pink is a complementary color to green, so choosing it for the character's shirt is a conscious decision. Pink will help the green look more vibrant, and the green likewise empowers the pink. I use RV11 (Pink) and RV10 (Pale Pink) here, trying not to blend them too smoothly this time – instead I want to create visible contrast to make believable creases in the clothing material.

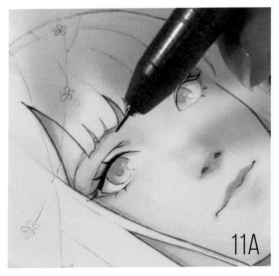

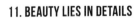

11. BEAUTY LIES IN DETAILS

The illustration may look very faint at the moment – the colors are pale and the whole thing looks unfinished – but as soon as I start adding little details, the change is drastic. I add more layers to the skin with V91 (Pale Grape) to create sharp manga-like shadows, then add some makeup with the same pink color that I used for the shirt (RV10) and a pink pencil. I add a layer of eyelashes with a very fine black Multiliner (0.03 mm) and the drawing starts to come alive (11A–11C).

12A

12. INKING THE LINE ART

The most satisfying part of the whole process is when I start adding the line art and seeing the illustration coming together. It is why I leave this part to last! If the line art was finished at the beginning, not only would I risk getting the colors dirty, smudging and fading the lines with alcohol markers, but I could also end up overworking the colors, adding more and more, and darkening the picture. Finalizing the line art now has so much more impact; it makes the drawing look finished to me, stopping me from adding more and more without an end in sight. I use gray, sepia, and black Multiliners where I think they will work best (12A and 12B).

TIP: USE A COLOR WHEEL AND RESEARCH COLOR THEORY TO HELP CHOOSE COLORS THAT WILL LOOK GOOD TOGETHER.

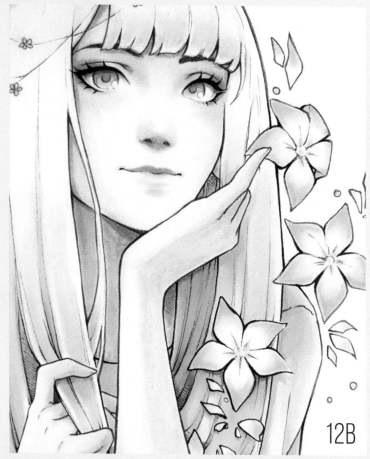

12B

13. FINAL TOUCHES

When making an illustration on a white background, the last thing I do is create a soft outline around the whole figure. This signifies a definite end of the process for me, and softens the transition between the sharp line art and the clean white of the background. I use a light Copic C2 (Cool Gray) marker for this image, but sometimes I try to match the outline more with the color palette of the illustration.

TIP: MARKER COLORS OFTEN CHANGE AFTER DRYING. IT IS GOOD TO HAVE A SHEET OF THE SAME PAPER THAT THE ILLUSTRATION IS MADE ON, JUST TO TEST COLORS, OR WITH NUMBERED REFERENCES OF ALL THE MARKER COLORS YOU HAVE.

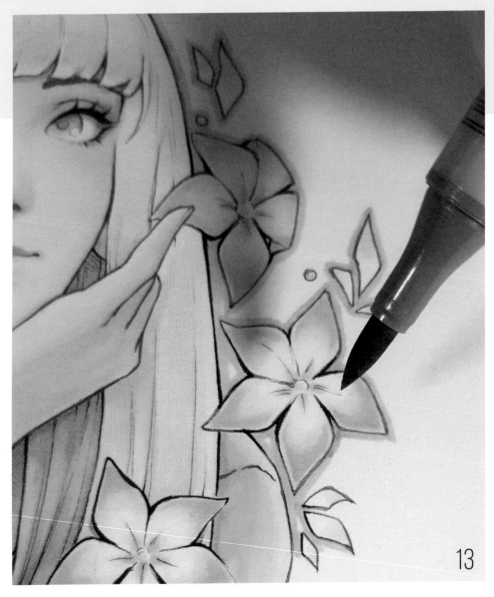

13

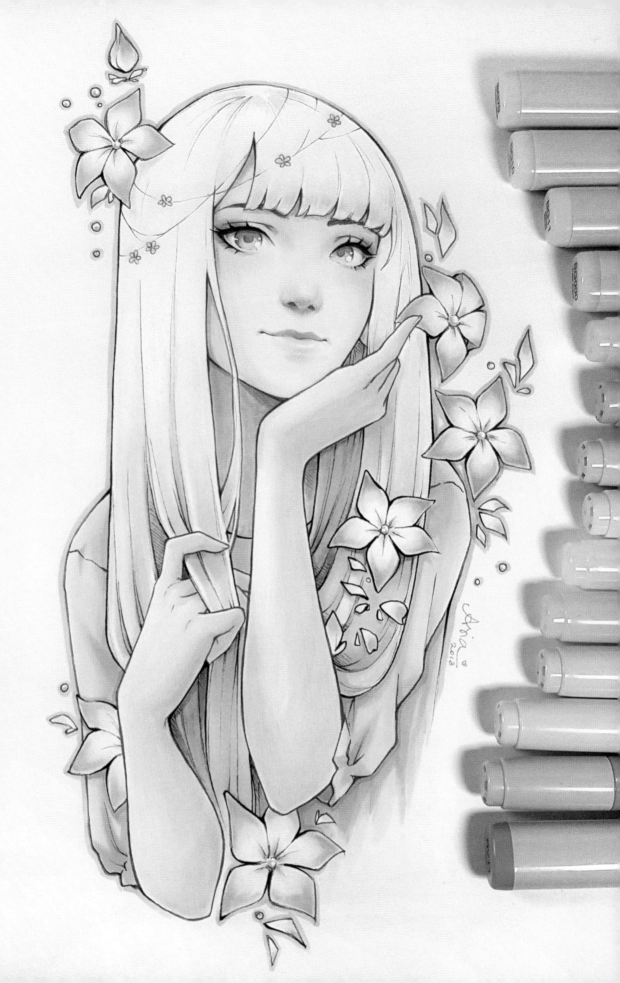

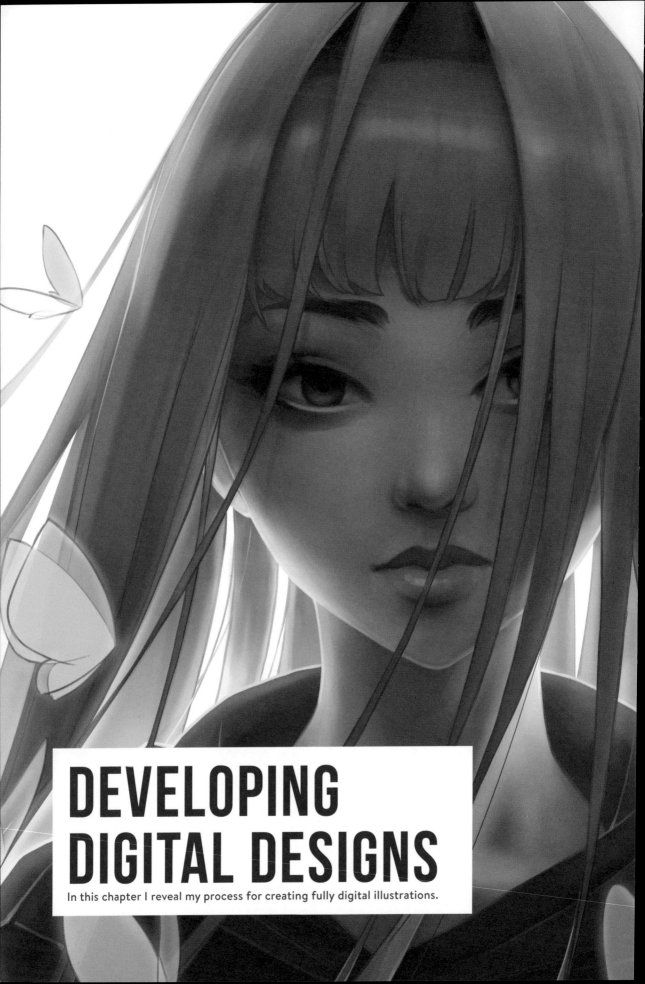

DEVELOPING
DIGITAL DESIGNS
In this chapter I reveal my process for creating fully digital illustrations.

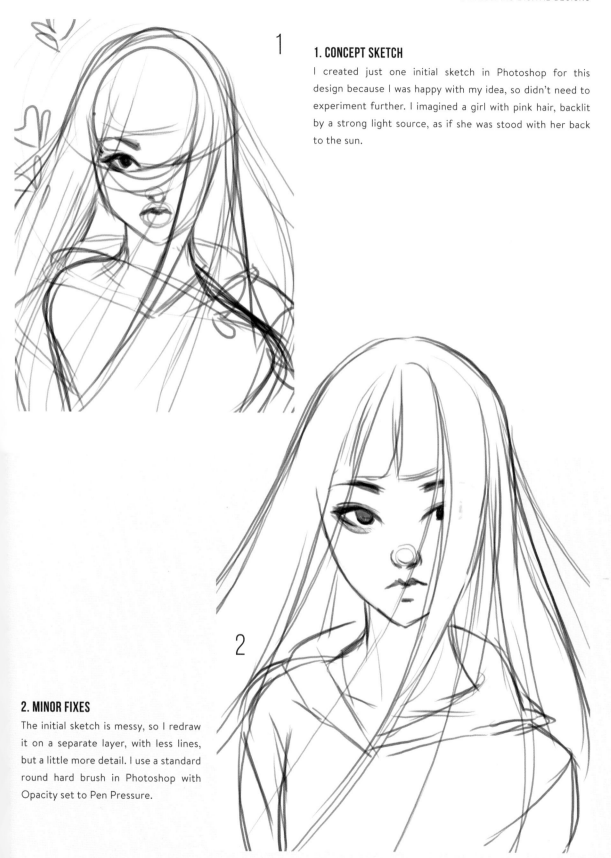

1

1. CONCEPT SKETCH

I created just one initial sketch in Photoshop for this design because I was happy with my idea, so didn't need to experiment further. I imagined a girl with pink hair, backlit by a strong light source, as if she was stood with her back to the sun.

2

2. MINOR FIXES

The initial sketch is messy, so I redraw it on a separate layer, with less lines, but a little more detail. I use a standard round hard brush in Photoshop with Opacity set to Pen Pressure.

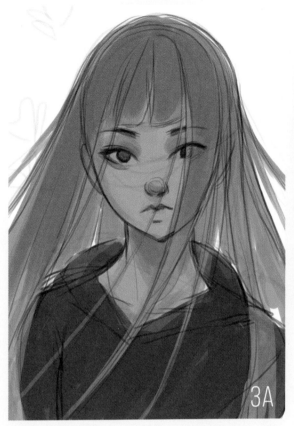

3. BASIC COLOR

I adjust the sketch a little and then apply the first stage of color on a layer below the sketch (3A). The colors are fairly dark and desaturated because the whole figure is in the shadow. I apply all color using the same brush, just bigger (3B).

4. MULTIPLY AND COLOR DODGE

To darken an element, create an additional layer and set to Multiply. Painting with the same color ensures consistency. I use this technique to add volume to the hair and face. I then use a Color Dodge layer to brighten the thinnest layer of hair that the sun shines through from behind, and add a touch of dark pink. I also quickly doodle butterflies to see if I can create a nice composition with their help. Then I switch off the layer so it doesn't distract me from what I am doing.

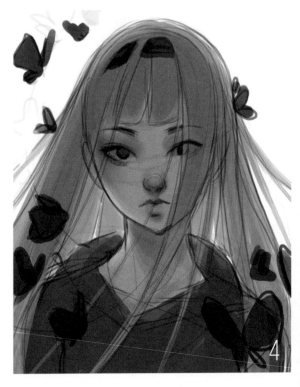

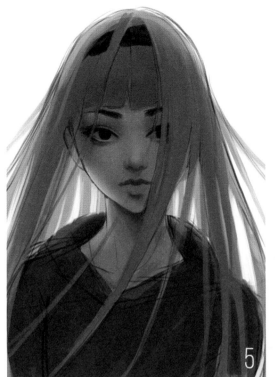

5. PAINTING AWAY

Next, I flatten all layers using the shortcut Cmd/Ctrl+Alt+Shift+E and adjust the face shape using the Liquify filter. I paint rather than using adjustment layers, and start to cover the sketchy lines with color.

6. ADDING SELECTION LAYERS

I decide to change my approach. Instead of painting the hair freely, I make two flat selections and fill with flat color. I use a bright shade for the lit-up hair and a darker shade for the front sections of hair that are in shadow.

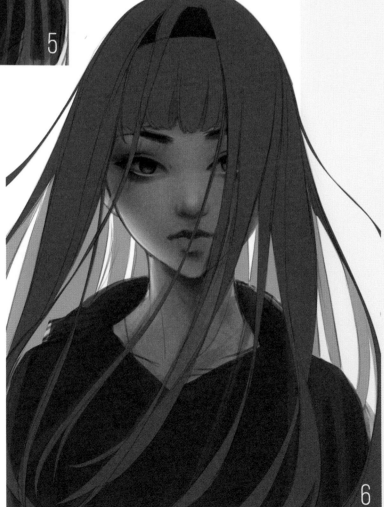

7A

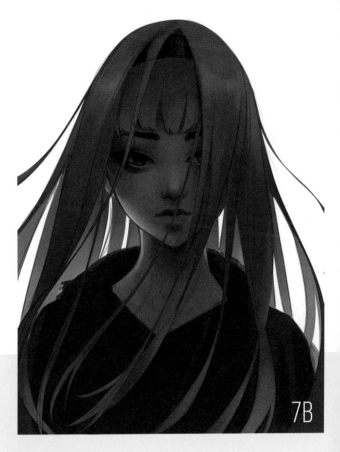

7B

7. DON'T GO OVER THE LINE!

Applying the Alpha lock option (7A), to lock transparent pixels on a layer, allows you to paint the layer without going over the lines, which is why I keep different elements on separate layers. I add highlights and shadows and darken the skin with an additional Multiply layer, painting with a soft brush where I want the color to appear darker (7B).

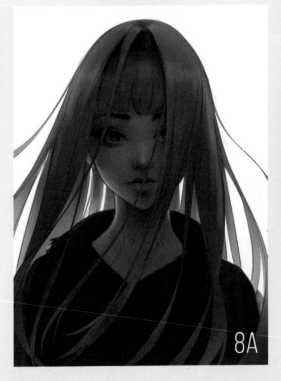

8A

8B

8. BACK LIGHT

When viewing someone against a bright light source, you can't see the outlines sharply. To soften the edges, I add Clipping Masks to the layers of hair and paint a lighter color where the shapes meet areas of bright white (8A and 8B).

9. DRAWING THE NECK

Although the design was drawn from my imagination, I struggled to visualize what the neck would look like. For reference, I took a photo of myself with my back against a window. The image helped me to determine the lighting of the neck and was also very useful when painting the clothing around it.

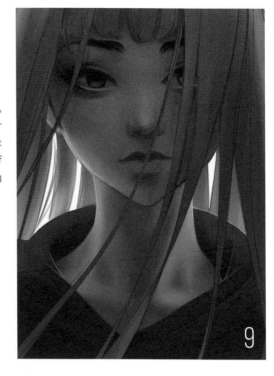

10. LINE ART

I like to bring special focus to the line art in my drawings. Being so strongly influenced by manga, I believe the line art is the most important aspect of a drawing. I use the same brush as I did previously, but smaller and with Shape Dynamics associated with Pen Pressure turned on. I decided to use brighter colors rather than darker shades to give highlights to the edges of the hair strands.

11. BUTTERFLIES

You may have noticed a few extra rounded shapes on the first initial sketch. Those lines were added to indicate butterflies. Now that the rest of the drawing is complete, I am ready to add them in. I use the color of the light pink hair and decide to keep the shapes simple, delicate, and appear almost transparent.

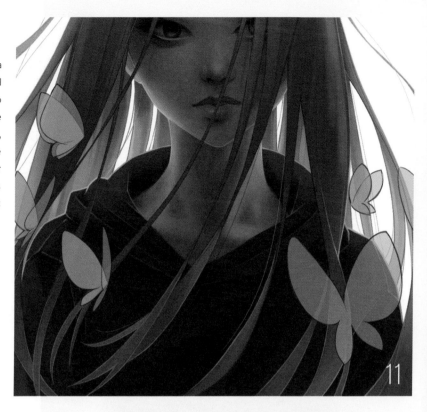

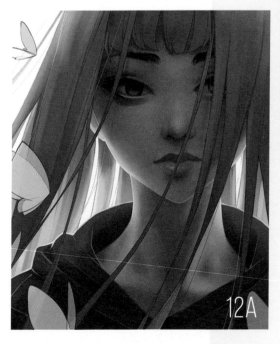

12. ADJUSTMENTS

To finalize the design, I add a few Adjustment layers, including Color Balance and Brightness/Contrast tweaks (12A and 12B). The very last layer is a slightly blurred copy of the finished picture, set to Overlay blending mode at 6% Opacity.

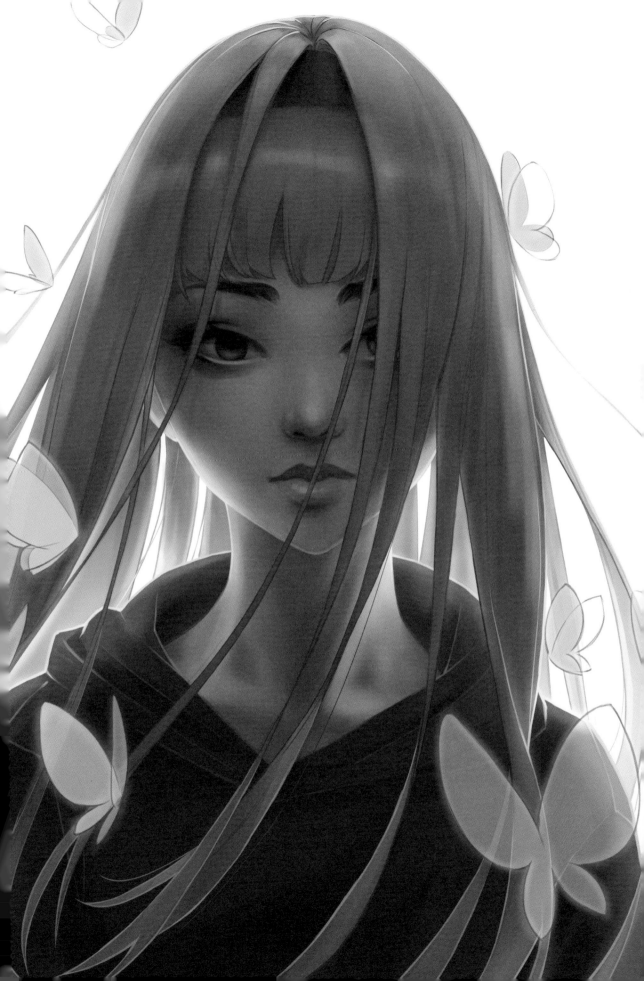

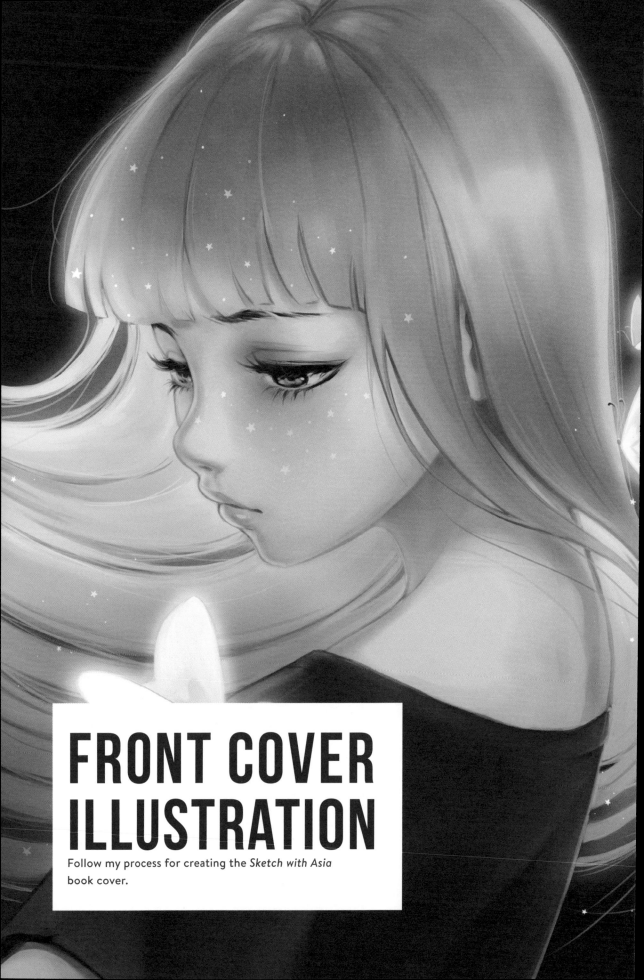

FRONT COVER ILLUSTRATION

Follow my process for creating the *Sketch with Asia* book cover.

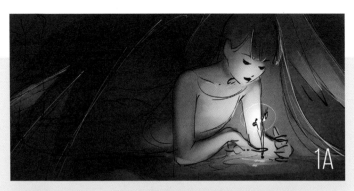

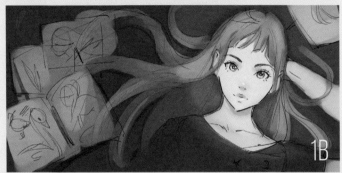

1. CONCEPT SKETCHES

I work on the cover as a flat landscape image that will be wrapped around the front cover, spine, and back cover, with the right-hand side being the front.

I come up with four concepts, eventually choosing the image on the bottom left, starting it with the same proportions as sketches 1A to 1C, and with very basic brush and generic colors and effects.

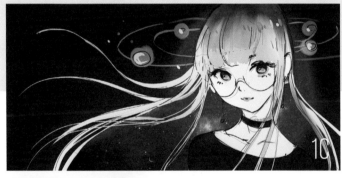

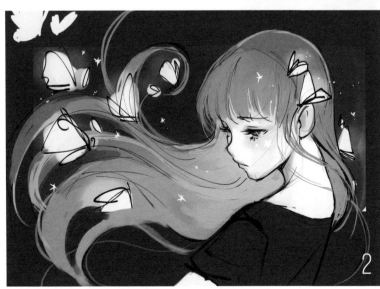

2. PROPORTIONS

Once the dimensions of the book are decided on, I adjust the size of the canvas to match. I also zoom out on the character, meaning I extend the canvas considerably on each side, and add details beyond where it would be cropped for printing purposes.

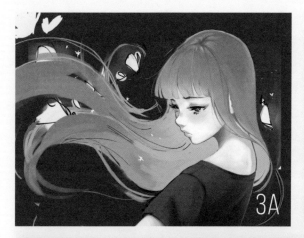

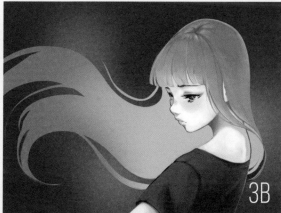

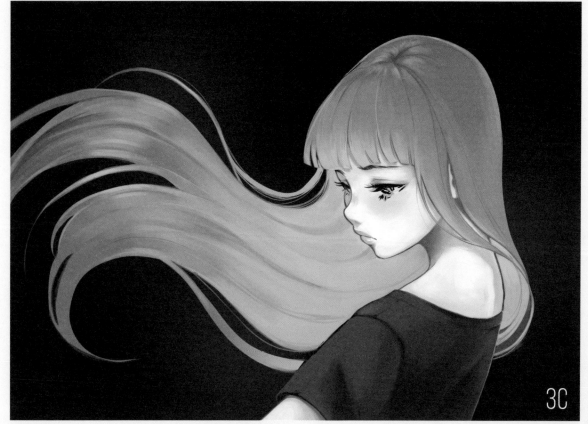

3. PAINTING

This is my first time designing a cover, so instead of drawing clean line art as I usually do, I start painting away on top of the sketch with colors (3A). I use a standard round brush for most of the process, and change Pen Pressure Opacity and Size as and when necessary. For now, all layers are set to Normal mode.

In the end, I find painting rather difficult so I partly revert to the old method, making a separate selection for the flowing hair (3B). I use a pen tool, filling it in on a separate layer. It is still a bit unusual for me as there is no line art, but with the shape already made it is a little easier to paint now.

When I increase the darkness of the background, I suddenly like the picture so much more (3C)! I start to slowly paint the hair, using aqua blue as a lighter tone to bring the highlights into the picture.

4. SHADOW, LIGHT, AND GLOW

To make the picture less flat and to separate the face from the glowing hair, I add a shadow to the character that appears more in the foreground, keeping the bright hair a part of the background (4A). This is just a flat gray layer set to Multiply.

Then I add some secondary light on the part of the face that is closest to the hair, neck, and front of the t-shirt (4B). The bright hair looks like it is glowing as there is so much contrast in the illustration, so naturally that light would have a strong impact on the areas it can reach.

Now I bring in the butterflies from the initial sketch (4C). Adding a Screen layer painted with a bright color of pink on the hair and of blue on the butterflies is what creates the glow effect. Also adding tiny stars and some light on the face in a glowing aqua color makes the picture more unified and magical.

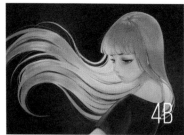
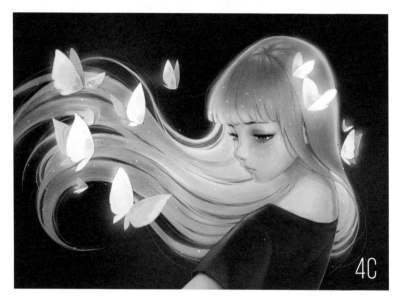

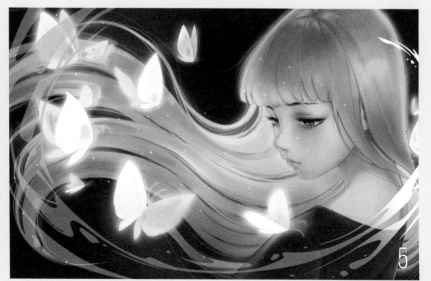

5. FINISHING TOUCHES

I add in a swoosh from the top left to bottom right, initially considering painting it with a neon color, but in the end making it become one with the artwork.

Finally, I move two butterflies on the girl's head so they won't get in the way of the book title.

Here is how the illustration looks, cropped to the book cover size but without the title.

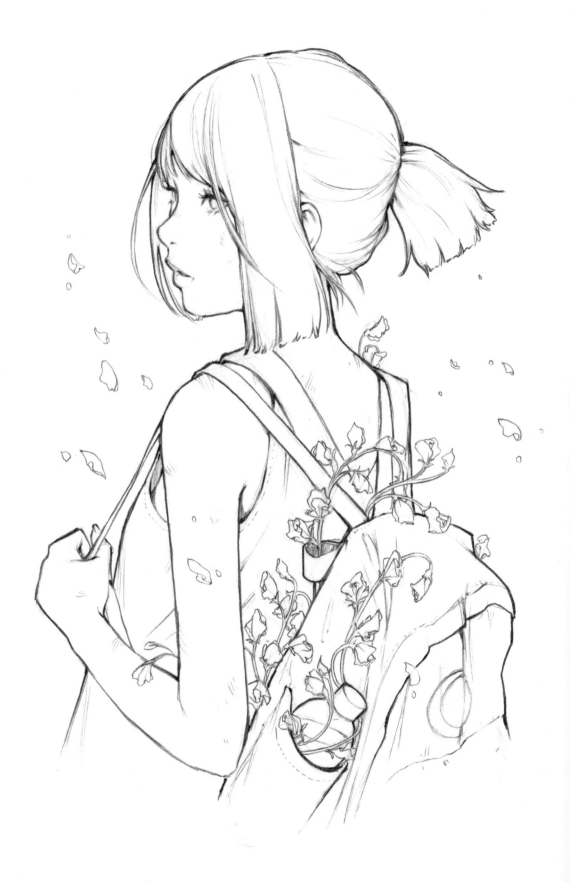

THANK YOU

Thank you. You, who are holding this book in your hands right now, for appreciating all the hard work of everyone who was involved in its making. Thank you to everyone who backed the *Sketch with Asia* Kickstarter campaign or shared the word about it – without you I wouldn't have been able to even dream of making this project a reality.

Thank you to everyone who follows me on social media, reaches out and supports me as an artist, whether that is through Patreon or any other way. Without you, I wouldn't be able to make anything that makes up the core of this book – all the art itself. You very much help and encourage me every day to keep going, and I hope that in this book you found some of that motivation for yourself. Thank you!

A massive thank you to the team at 3dtotal, for all the hard work, warmth, and encouragement, and of course for taking care of physically making and distributing this book.

Most importantly, thank you Mat, for all those things for which I'd probably need an extra 168 pages to list only some of them. Thank you, all the way, from here to the end of the universe and back.

And lastly, thank you Warren, for… everything. Especially for your help and support in making this book and making sure I don't lose (all of) my sanity.

3DTOTAL PUBLISHING

3dtotal Publishing is a leading independent publisher specializing in trailblazing, inspirational, and educational resources for artists.

Our titles feature top industry professionals from around the globe who share their experience in skillfully written step-by-step tutorials and fascinating, detailed guides. Illustrated throughout with stunning artwork, these best-selling publications offer creative insight, expert advice, and essential motivation.

Fans of digital art will find our comprehensive volumes covering Adobe Photoshop, Pixologic ZBrush, Autodesk Maya, and Autodesk 3ds Max must-have references to get the most from the software. This dedicated, high-quality blend of instruction and inspiration also extends to traditional art. Titles covering a range of techniques, genres, and abilities allow your creativity to flourish while building essential skills.

Well-established within the industry, we now offer over 50 titles and counting, many of which have been translated into multiple languages the world over. With something for every artist, we are proud to say that our books offer the 3dtotal package.

Visit us at 3dtotalpublishing.com

3dtotal Publishing is an offspring of 3dtotal.com, a leading website for CG artists founded by Tom Greenway in 1999.

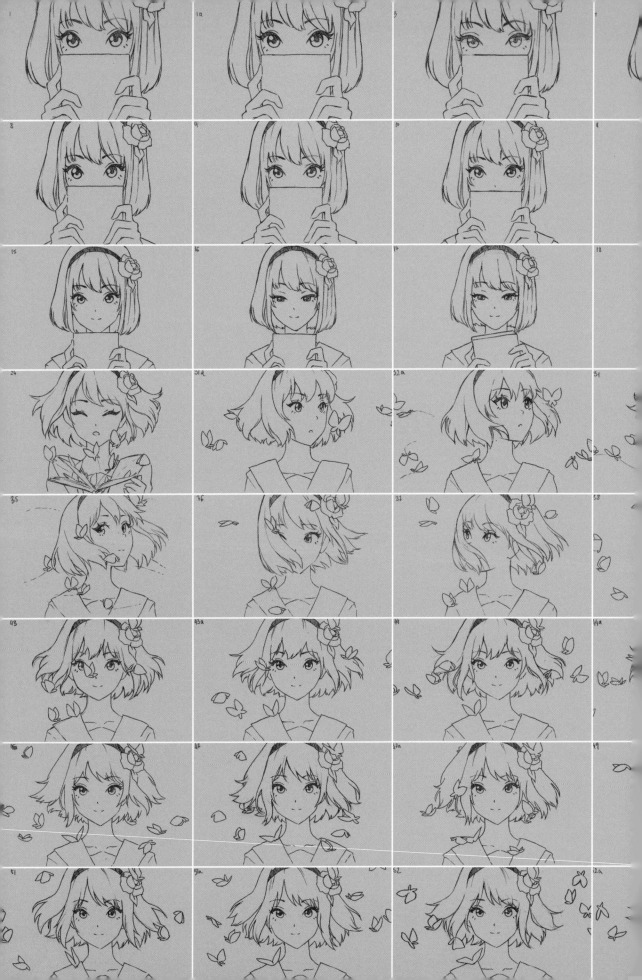